Detroit Revealed

A Different View of the Motor City

Leslie Cieplechowicz

AMERICA
THROUGH TIME®
ADDING COLOR TO AMERICAN HISTORY

*Dedicated to my mom who always believed and
my dad who would walk through hell to rescue me.*

America Through Time is an imprint of Fonthill Media LLC
www.through-time.com
office@through-time.com

Published by Arcadia Publishing by arrangement with Fonthill Media LLC
For all general information, please contact Arcadia Publishing:
Telephone: 843-853-2070
Fax: 843-853-0044
E-mail: sales@arcadiapublishing.com
For customer service and orders:
Toll-Free 1-888-313-2665

www.arcadiapublishing.com

First published 2022

Copyright © Leslie Cieplechowicz 2022

ISBN 978-1-63499-406-4

Typeset in Gotham Book
Printed and bound in England

Contents

About the Author

Leslie Cieplechowicz is a photographer who developed her craft by working the streets of Detroit as a paramedic and shooting old, historical buildings she found on her runs. Her love of creating unique imagery lead her across the state, then the United States, then globally, where she currently finished shooting in the country of Georgia, documenting its lively culture, diverse people, and vast expanse of classical, ornate architecture from its Soviet era. She currently works as an instructor after leaving the road and spreads her love of photography to her students.

Introduction

My partner navigated the soot-streaked ambulance through a poisonous fog, avoiding the swollen fire hoses dripping water onto the dusty asphalt. When I stepped out of the rig into the inky darkness, pierced by the headlights from our rig and the crimson and amber lights on the fire trucks, smoke laden with the odor of a dying house stung my nose. Out of the haze stepped a wet, ashy firefighter cradling a five-year-old girl in his arms, her head lolling to the side. Without speaking, he thrust her into my arms. With the child, I darted into the back of the rig and began emergency care by cranking up the oxygen and breathing for her with a bag-valve-mask device. My partner peered through an opening to the cab of the ambulance, his whitened knuckles clenching the black steering wheel. "Children's Hospital?" he asked. "Yes," I replied as the ambulance sirens began to wail.

I have always had an affinity for Detroit but working the streets for years as a paramedic for the Detroit Fire Department created a love for the city and its residents, gritty, funny, tough people who weathered the varying opinions, sometimes negative, about their town through the years. While responding to calls, I saw sites in Detroit that were well known only by the locals, places where the neighborhood residents gathered, chatted, and laughed.

Detroit has a reputation that has fluctuated throughout the decades, from the glowing automotive capital of the world to an aging city on the comeback. I would like to give you my perspective, showing you a place of beauty, of quiet charm, of spots that are a pleasure to visit, a Detroit unrevealed to many outside the city, where surprises are around every corner and the residents are warm and charming. It is the city and people I grew to love as I provided care to them. It is a city that I had the honor to work in.

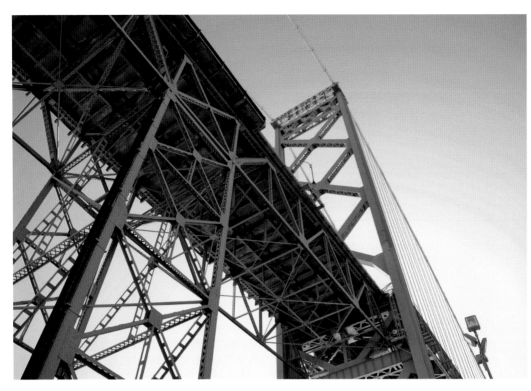

A view of the Ambassador Bridge from Riverside Park.

A young couple hanging out and having fun on the city streets.

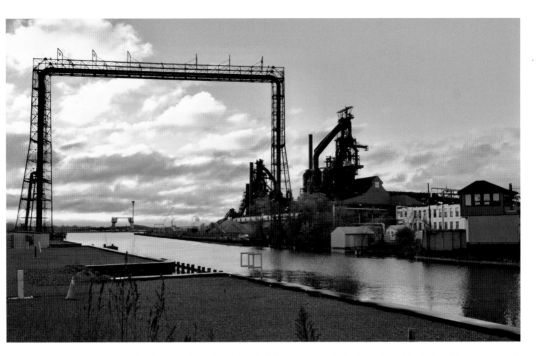

Zug Island, a man-made island, on the industrial end of the city, a remainder from Detroit's steel and iron works past.

Loyal Order of Moose Lodge on 2215 Cass Avenue, as dusk descended and an ice storm splattered the roads.

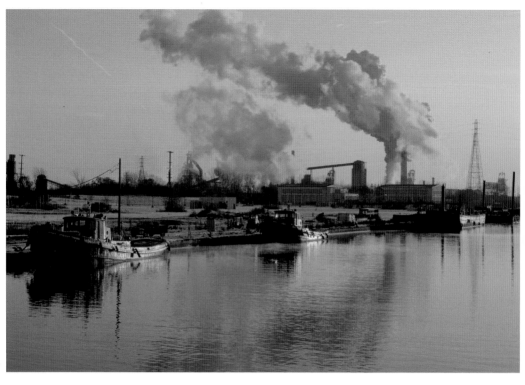

The industrial southside of Detroit bathed in an amber haze.

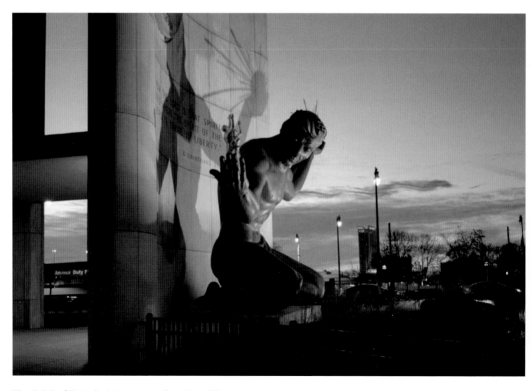

The Spirit of Detroit statue across from Hart Plaza.

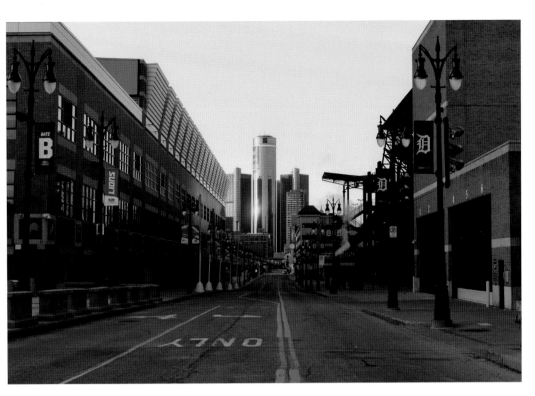

A view down Brush Street, with Comerica Park on one side and Ford Field on the other.

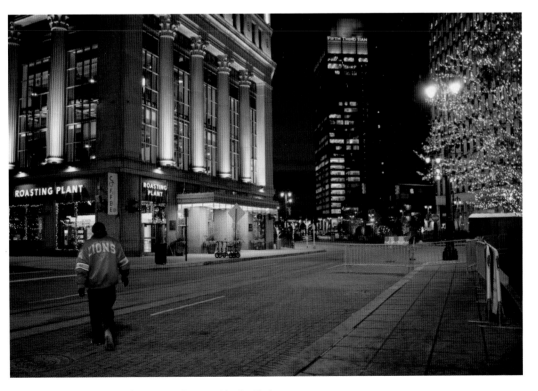

Under the streetlights next to Campus Martius Park.

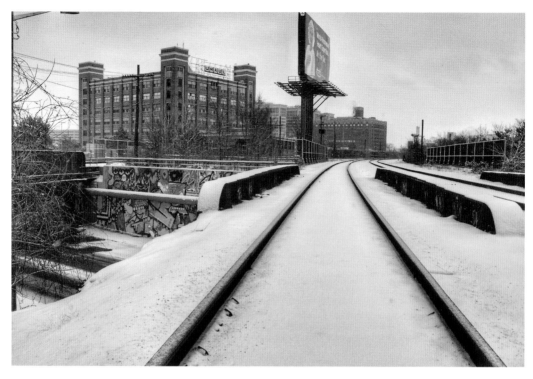

Train tracks over the Lodge expressway curving into the horizon on a chilly, winter day.

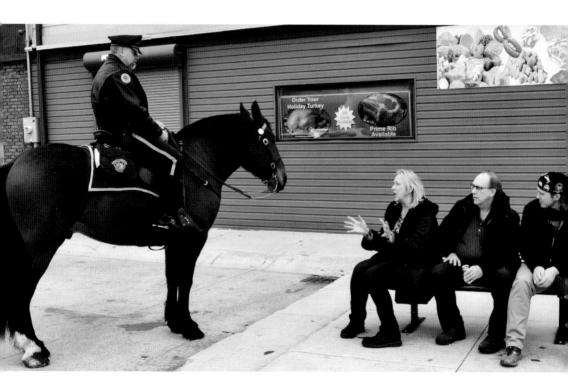

A mounted Detroit police officer talks to a family at the Eastern Market.

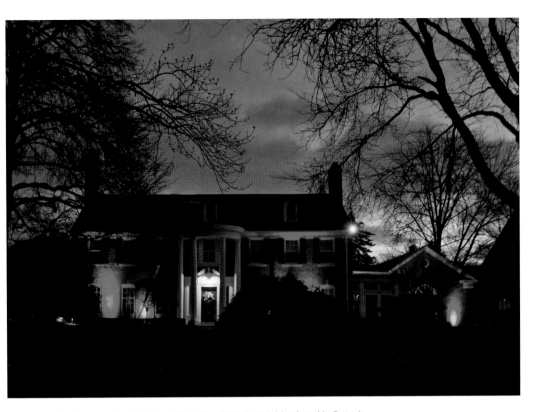

A glowing mansion in Palmer Woods, a historic neighborhood in Detroit.

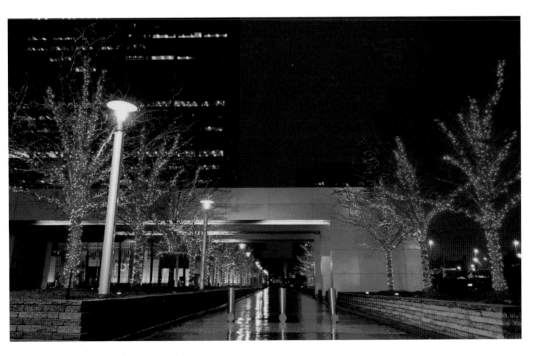

Holiday lights in downtown Detroit.

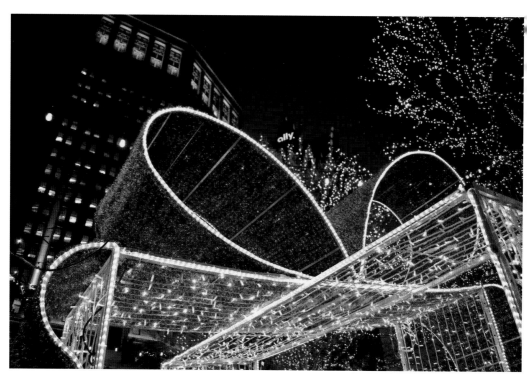

Twinkling lights sparkling at Campus Martius.

Most Holy Redeemer Church, once noted as the largest Catholic Church in North America, in Mexican Town.

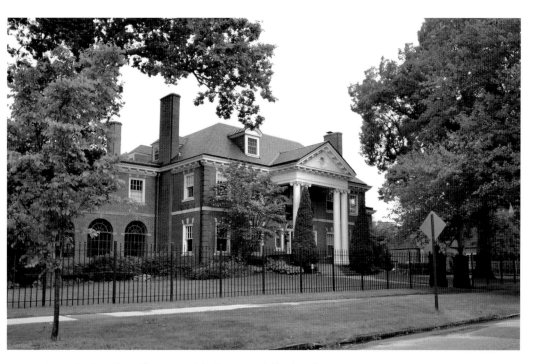

A mansion in Indian Village, one of the historic neighborhoods in Detroit.

A man with a Red Wing jersey walks down Woodward Avenue.

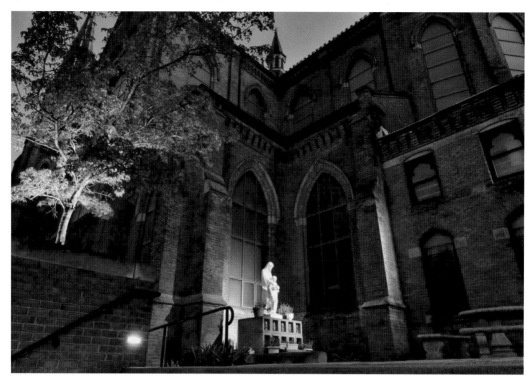

The Basilica of Ste. Anne De Detroit, the oldest church in the city.

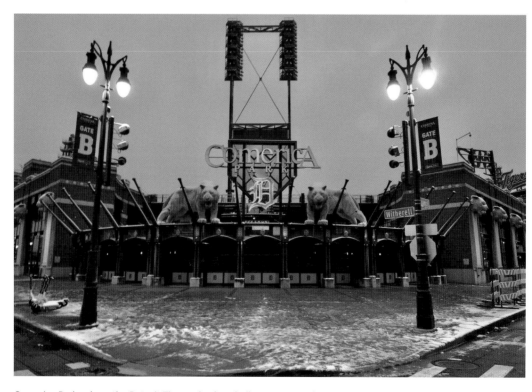

Comerica Park, where the Detroit Tigers play baseball, on a snowy dawn.

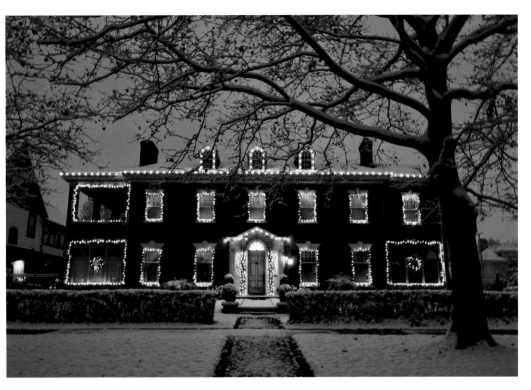

A mansion, sparkling with Christmas lights, in Indian Village, one of the historic neighborhoods in Detroit which includes Boston-Edison and Palmer Woods.

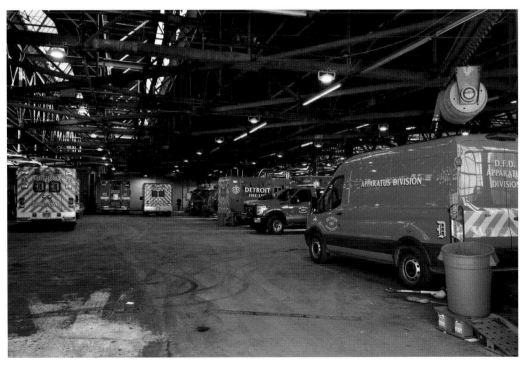

Detroit Fire Department rigs waiting for the mechanics.

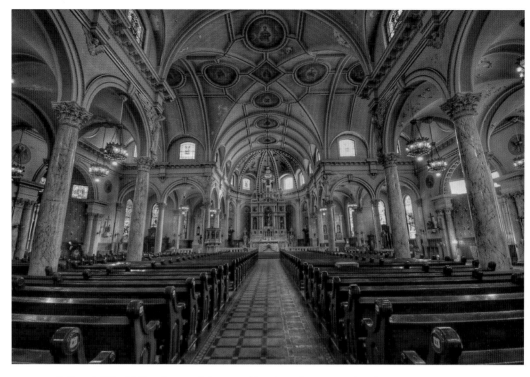

St. Francis D'Assisi Church, one of the many historic and gorgeous churches in the city.

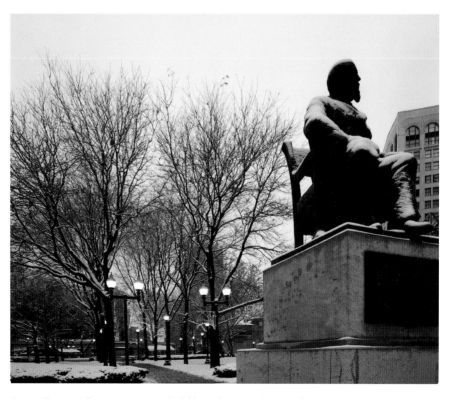

Hazen Pingree, a former governor of Michigan, keeps a silent, cold watch over Grand Circus Park.

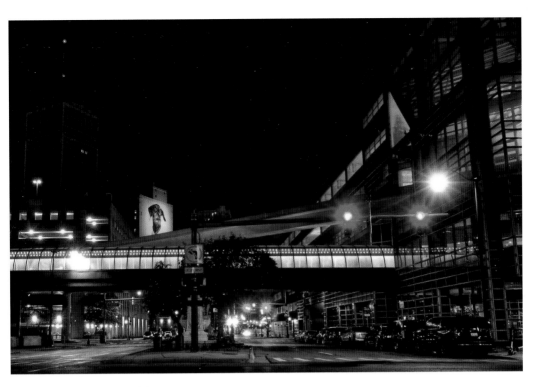

Randolph Street at night.

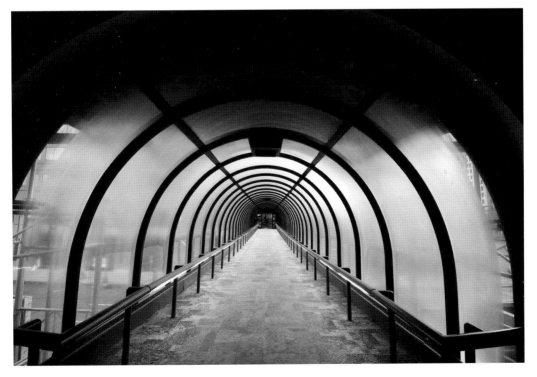

The walkway connecting the Fisher Building to the Henry Ford Medical Center.

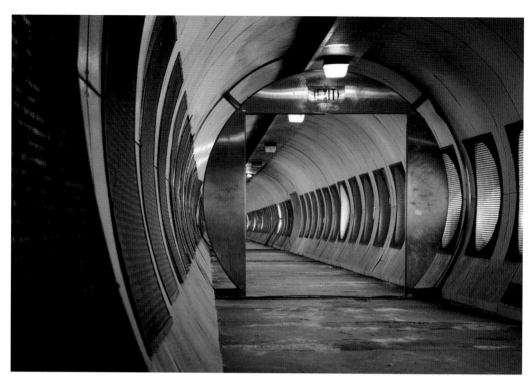

The tunnel leading from the parking structure to Joe Louis Arena, former home of the Red Wings hockey team.

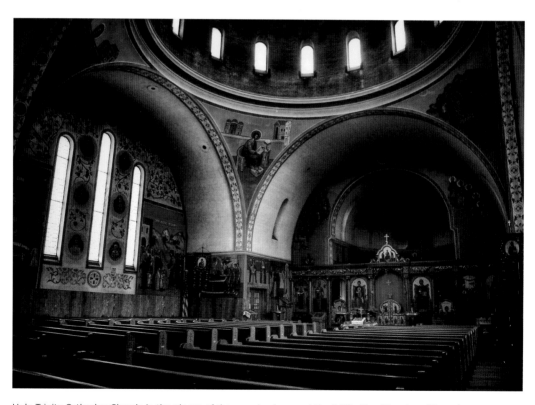

Holy Trinity Orthodox Church, in the gloom of the morning hours, at the 8 Mile Road border of Detroit.

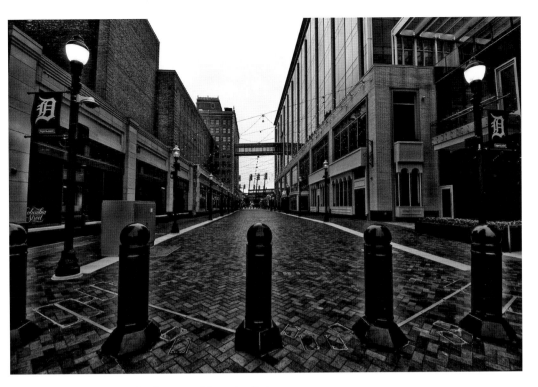

E. Columbia Street leading toward Comerica Park.

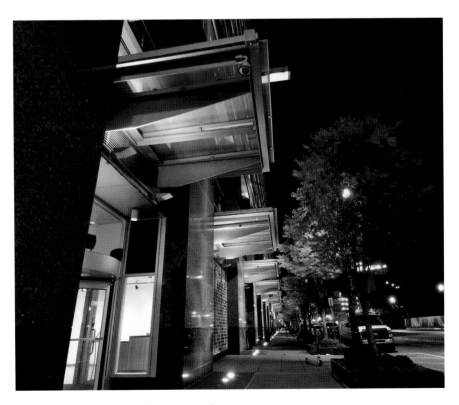

Farmer Street aglow on a cool autumn evening.

Two men enjoying Cadillac Park in the morning.

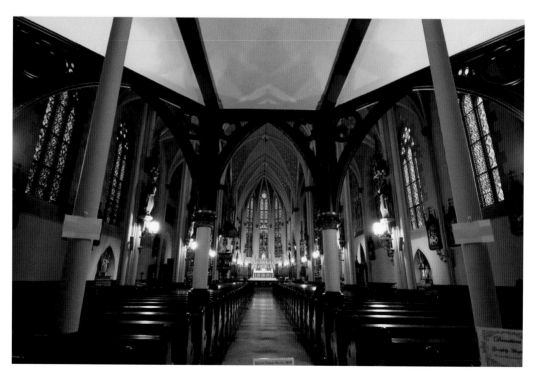

Historic Trinity Lutheran Church located near the Eastern Market.

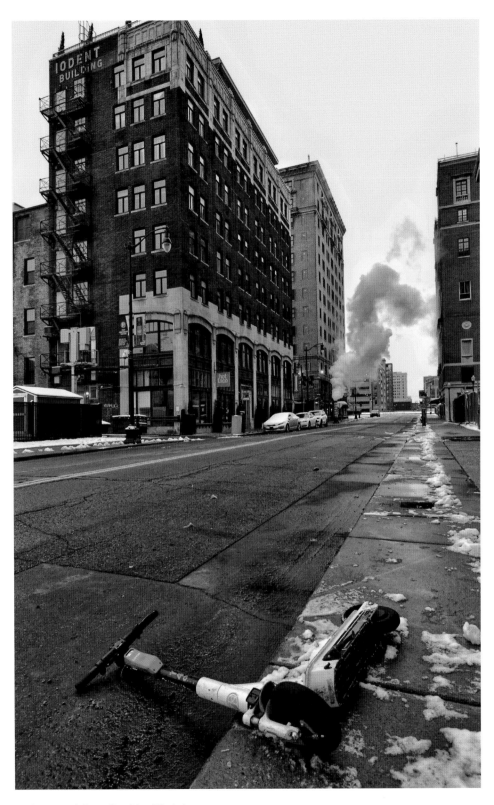

A scooter lolls on the side of Park Avenue.

1

A Plethora of Parks

As the crimson morning sun paints a smear of gold across the horizon, its brilliance illuminates the steel girders on the Ambassador Bridge crossing over to Windsor, Canada, creating a turquoise etching over the Detroit River. Canadian geese honk and complain as they float on the azure river waves then burst into flight. Shadowy silhouettes wrapped in light jackets hunch next to their fishing poles, lines dangling in the water, as their breathes create soft, white clouds in the crisp, dawn air. A couple with their fluffy, cream mutt tugging at the leash meander through the silence along the riverfront. This is a scene from Ralph C. Wilson Centennial Park, also known as West Riverfront Park, at 1801 West Jefferson.

Detroit is a city with gems of parks tucked here and there, just waiting to be explored. One of the largest is the International Riverfront, a series of parks spanning 5.5 miles, snaking from the Ambassador Bridge down to Belle Isle. The Detroit Riverfront Conservancy, a 501c3 organization, realized early on the importance of preserving public access to the river and enhancing its beauty. The 501c3 organization raised funds of over a half a billion dollars to develop this important stretch of land. The riverfront also contains part of the Detroit River International Wildlife Refuge, an important preserve for aquatic flora and fauna.

One of the busiest parks along this ribbon of land is the Cullen Plaza at 1340 Atwater Street. With spacious parking and a building housing a food vendor along with restrooms, this park is a perfect place to see the beauty of the Detroit and Windsor skyline. The park also boosts a whimsical carousel with colorful water dwelling creatures that are indigenous to the Detroit River, just beckoning you for a ride. The Cullen Family Carousel was created by Briggs Design and handcrafted specifically for the Detroit Riverfront.

The 31-acre William G. Milliken State Park and Harbor, named in honor of the former Michigan governor William G. Milliken, is located at 1900 Atwater St. and just east of the Renaissance Center. The park has a fifty-two-slip harbor that is guarded by a cylindrical 63-foot-tall lighthouse. A small wetland area is designated for wildlife and a sculpture of a bee pays homage to these important insects.

Riverside Park sprawls west of the Ambassador Bridge at 3511 W. Jefferson St. Concrete ramps invite skateboarders to test their prowess and skills while a play area encourages younger kids to enjoy the outdoors. Fishermen and women can be seen at all hours chatting and enjoying the turquoise waters of the Detroit River. Further west, the remnants of the Boblo Boat dock, where two historic vessels once took Detroiters to an island amusement park, can be seen.

Further east is the 52-acres Maheras-Gentry Park at 12550 Avondale. This beautiful, secret ninety-year-old place is more familiar with the locals and offers a wonderful view of the Detroit River, along with basketball courts, picnic tables and a playground. A bicycle path offers the perfect trail to take a spin or just relax and gaze at the terrific view of the Detroit skyline. Waterfowl like to float in the park's pond that connects to the river and a small bridge allows for the best bird watching.

An absolute gem of Detroit is Belle Isle, a 982-acre state-owned island park sitting in the Detroit River and accessible by the historic 2,193-foot MacArthur Bridge built in 1923 with its nineteen arches. On the island are multiple biking and hiking paths looping around wetlands, forests, and historical Detroit architecture. The James Scott Memorial Fountain constructed in 1925 with a diameter of 510 feet is guarded by stone lions and playful angels. The remains of the zoo still can be viewed along the wooded river path along with vintage casino whose facade harkens to a former time. Beaches and parks areas are strewn throughout the island along with a municipal golf course. The oldest aquarium can be found here with its intricate exterior and bright lime tile on the inside. If you want to get lost in fauna from around the world, go to the Anne Scripps Whitcomb Conservatory from 1904, the oldest in the nation. Resting on the island is the old Belle Isle Police Station with large grand doors for police horses, built to maintain order on isle. In 1928, a dispatch was established, and radio calls were broadcast. In 2014, when the island was taken over as a state park, conservation officers and state troopers now keep the peace. Another historic fixture is the Detroit Yacht Club, established in 1868, perched on the north side of the island. The building sits on its own man-made private island and was designed by George D. Mason, in the classic Mediterranean Revival style. Other features of the isle are a golf range, a historic casino, and the Dossin Great Lakes Museum, highlighting the history of the Great Lakes.

A historic park worth a visit is the 93-acre Fort Wayne at 6325 West Jefferson, sprawled along the Detroit River. Built in 1845, many of the existing structures remain, such as the limestone barracks, the fort, officers' quarters, hospital, shops, commissary, guard house, and stables. Built to protect against the British, the fort use fizzled after the United States and Britain relations improved, and so it sat vacant for ten years. The fort regained relevance during the American Civil War, when the North feared the Confederacy sympathizing British would attack from Canada. The park now provides an opportunity to stroll back into the past while watching freighters chug down the river.

Hart Plaza borders the Renaissance Center with the Detroit River flowing on their southsides. Opened in 1975, the plaza contains the famous Horace E. Dodge and Son Memorial Fountain, whose silvery circle spouts water onto the hot pavement to cool river walkers. Hart Plaza hosts numerous festivals throughout the summer, including the Windsor-Detroit International Freedom Festival, with its spectacular, striking display of vibrant fireworks to celebrate the 4th of July. A large, open amphitheater provides the stage and seating for these celebrations and its backdrop is a wonderful view of downtown.

The Dequindre Cut Greenway, which opened in 2009, follows an old Grand Trunk Western Railroad line path, no longer in use, from the south of Mack all the way to the river with accesses at Atwater Street, Franklin Street, Woodbridge Street, Lafayette Street, Gratiot Avenue, Wilkins Street, and Mack Avenue. Street art by local artists and graffiti decorates the tunnels and concrete walls along the way. You can take a leisurely stroll or hop on your bike and follow the 20-foot-wide asphalt path. A BCBSM outdoor fitness park is found at the Woodbridge access.

The Monroe Street Midway, at 32 Monroe Street, opened in 2021, is a huge outdoor park with a roller rink, four half basketball courts, a multi-use sports court, and beautiful artwork from noted artists, such as muralist Phill Simpson and contemporary Olivia Guterson. There is no entrance fee and roller skating is only $13, including skate rental. Enjoy the fresh air or play under the stars next to Detroit's Campus Martius while listening the songs spun by local DJs.

Beacon Park, at 1901 Grand River Avenue, opened in 2017, is a one-acre park that is known for its year-round light installations which is suitable as the park was developed by DTE Energy. The contemporary park boasts a flagship Lumen, which is Latin for light, and where you can view the glow of Detroit through walls of glass.

At 800 Woodward is Campus Martius Park, a park nestled in downtown Detroit. Framed by a dramatic skyline, the park is known for its ice rink in the winter along with a huge glowing Christmas tree and sparkling lights twisted around metal frames forming holiday sculptures. You can take a carriage ride down the streets

and watch the snowflakes drift down, then have a bite to eat at the restaurants in and around the park. Other events are hosted here throughout the year including food and wine festivals and fitness classes.

Palmer Park at 910 Merrill Plaisance Street is a 296-acre park that was designed in the 1800s with oak trees that are more than 350 years old. The park has numerous attractions including the historic marble fountain for the Detroit Opera house, the stable for the Detroit Police Mounted Division, a lighthouse next to a large pond with waterfowl, a notable log cabin, and numerous trails for jogging, walking, and biking. The park is a perfect place for a leisurely stroll in any season.

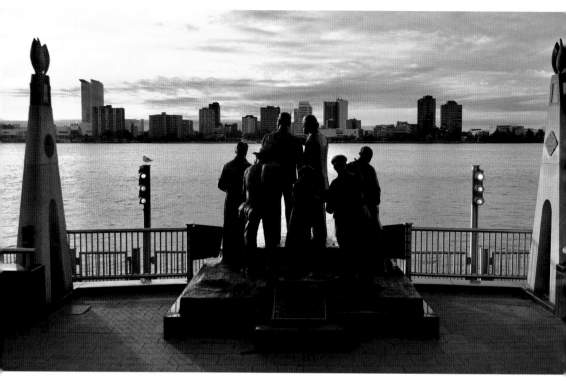

Gateway to Freedom International Memorial to the Underground Railroad looks out over the Detroit River at Hart Plaza at its companion sculpture, Tower of Freedom, over in Windsor.

The open amphitheater at Hart Plaza.

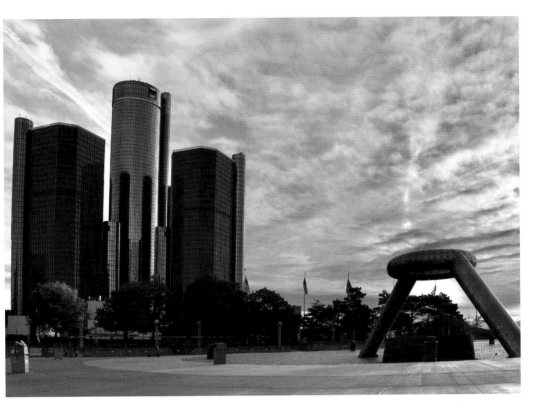

The Renaissance Center looms over the Horace E. Dodge and Son Memorial Fountain at Hart Plaza.

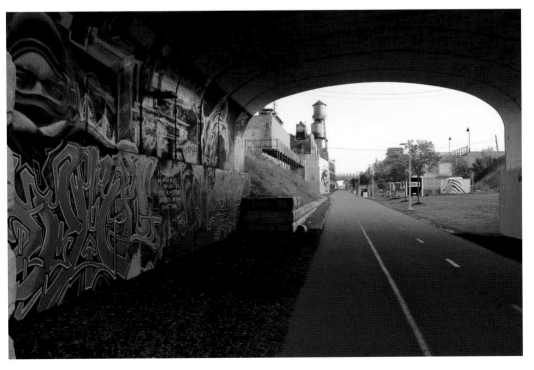

A tunnel under the road on the Dequindre Cut highlighting colorful graffiti.

A man taking a break from his walk on the Dequindre Cut.

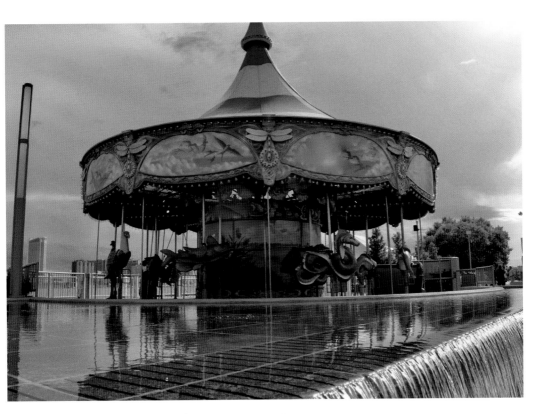

Cullen Plaza with its carousel of water creatures.

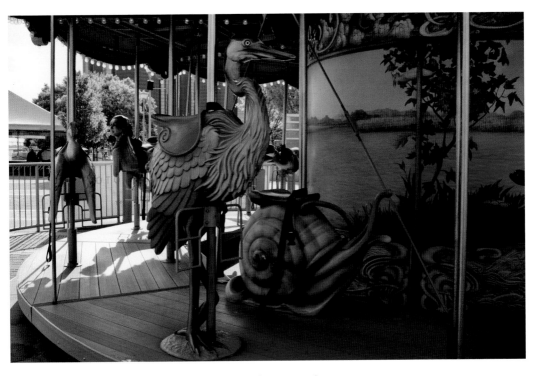

A heron and a snail await riders on the Cullen Plaza carousel.

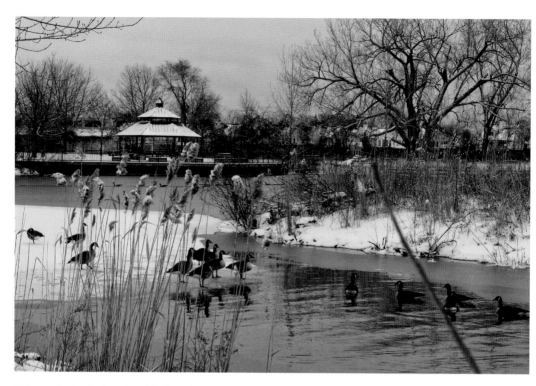

Maheras-Gentry Park under a blanket of powdery snow and crisp ice.

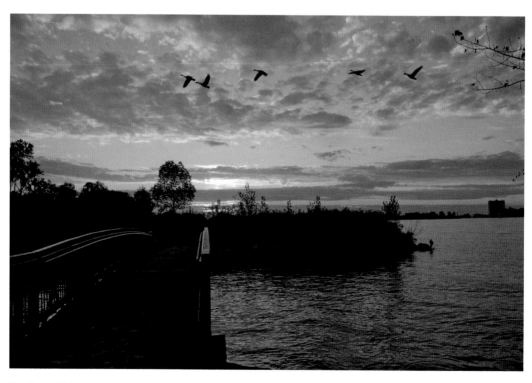

Sunrise at Maheras-Gentry Park in autumn as the geese are strengthening their young for the migration flight down south.

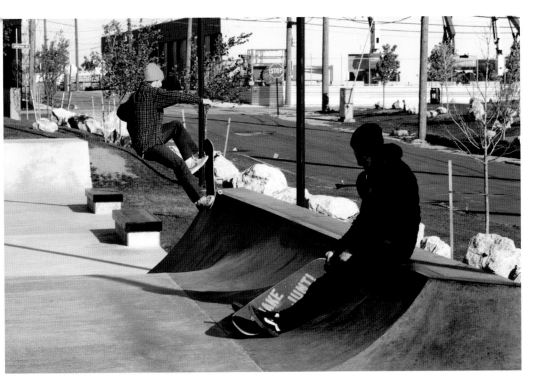

A guy shows his moves to his friend at Riverside Park's skate park.

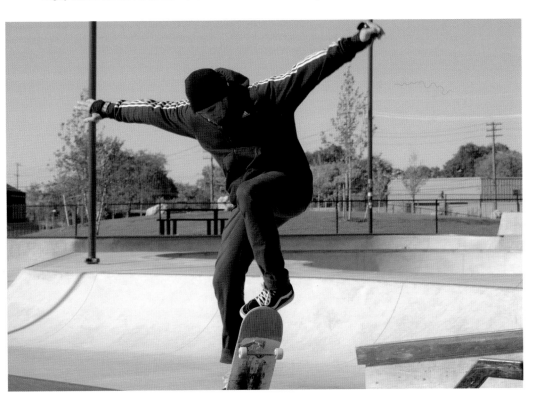

A young man goes airborne at Riverside Park.

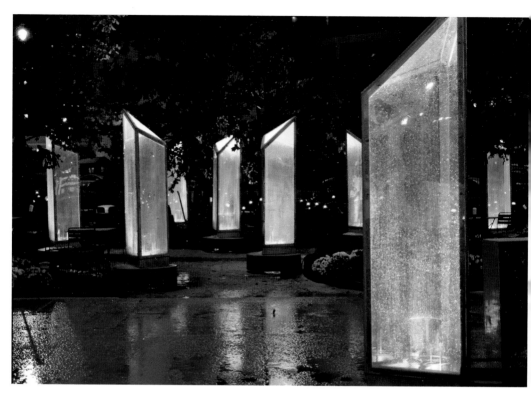

Glowing prisms dripping color at one of the light shows at Beacon Park.

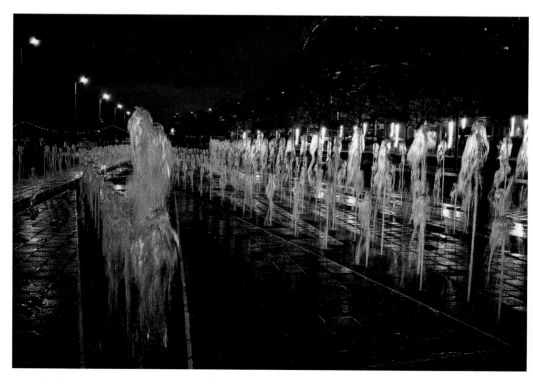

A dancing fountain playing in the darkness and gleam from the Renaissance Center along the Detroit Riverwalk.

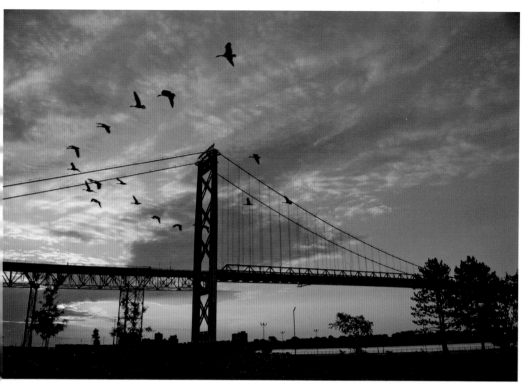

The Detroit sky dabbed with golden fleece at dawn at Riverside Park.

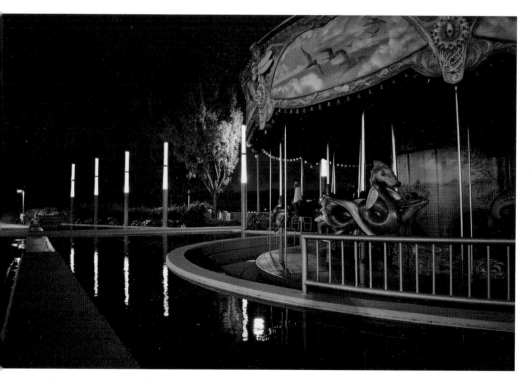

Cullen Plaza under the flickering stars.

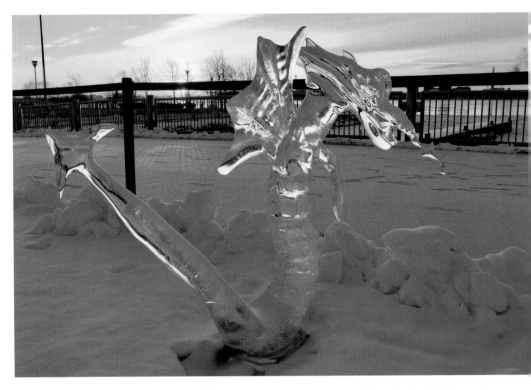

The fingers of dawn piercing an ice-carved dragon during an ice sculpture exhibit on the Detroit Riverwalk.

Vibrant fall colors at Palmer Park.

An emerald and azure mural on the handball courts at Palmer Park.

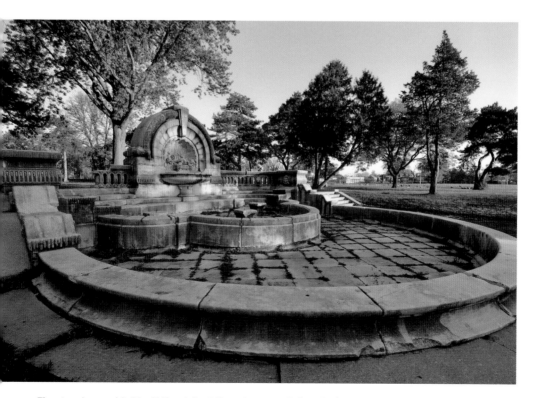

The stunning marble Merrill Fountain at the entrance to Palmer Park.

A Detroit Police Mounted Division horse relaxing in the cool morning at Palmer Park.

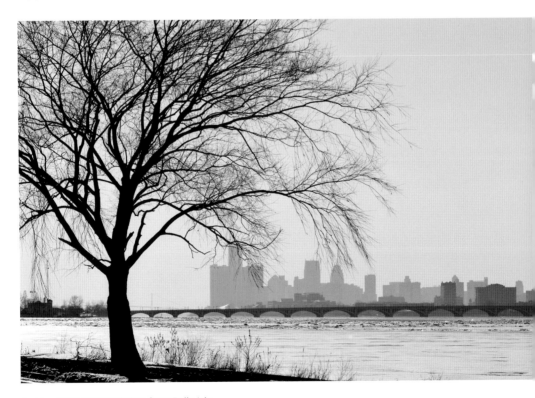

A view of the Detroit skyline from Belle Isle.

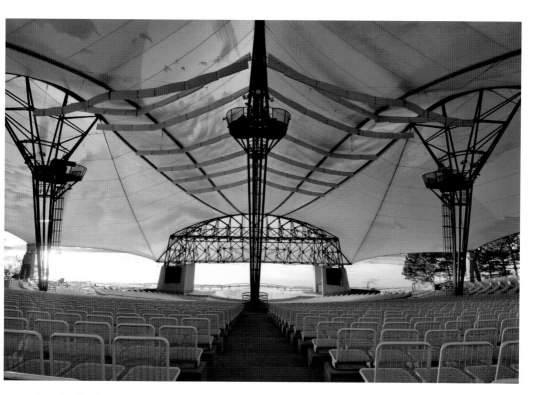

The Aretha Franklin Amphitheatre, an outdoor concert venue, along the Detroit Riverwalk.

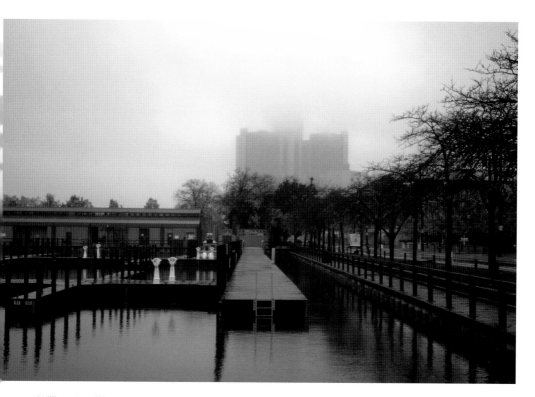

William G. Milliken State Park and Harbor in the fog.

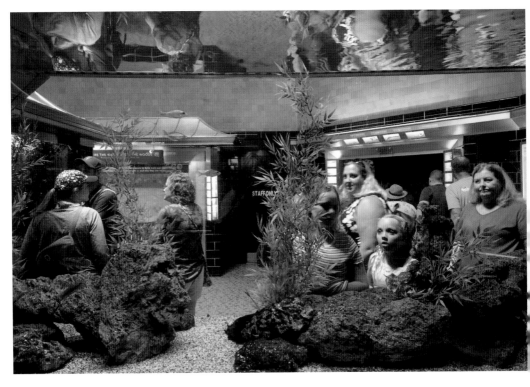

A young girl peers into the watery tank at the Belle Isle Aquarium.

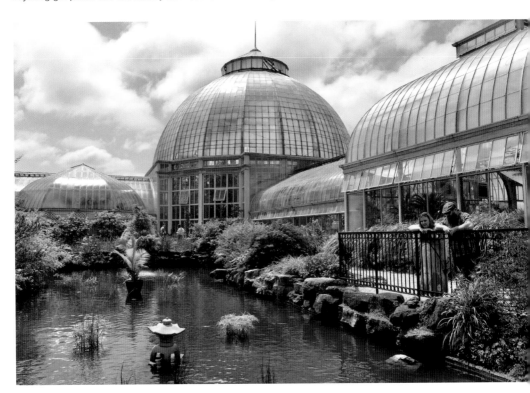

A couple watch the koi fish in the pond at the Belle Isle Conservatory.

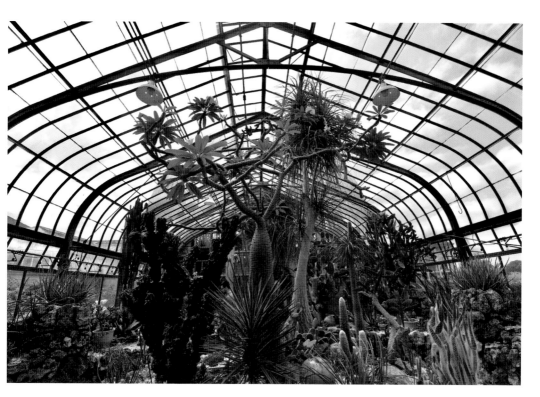

Inside the Belle Isle Conservatory.

Detroit Yacht Club on Belle Isle at sunrise.

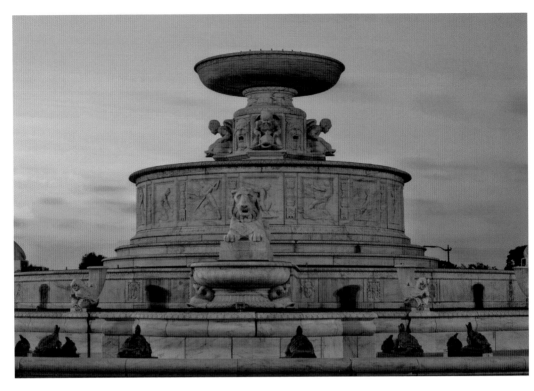

James Scott Memorial Fountain on Belle Isle.

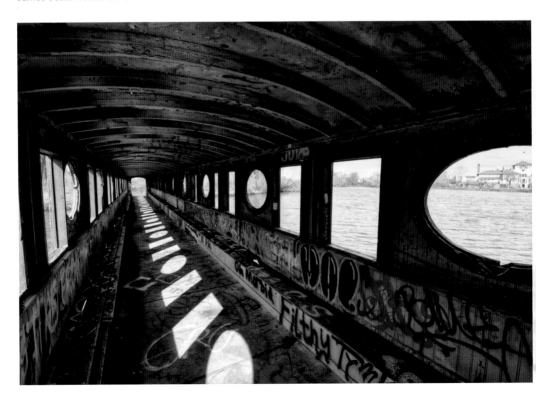

A concrete foot bridge decorated with graffiti on Belle Isle.

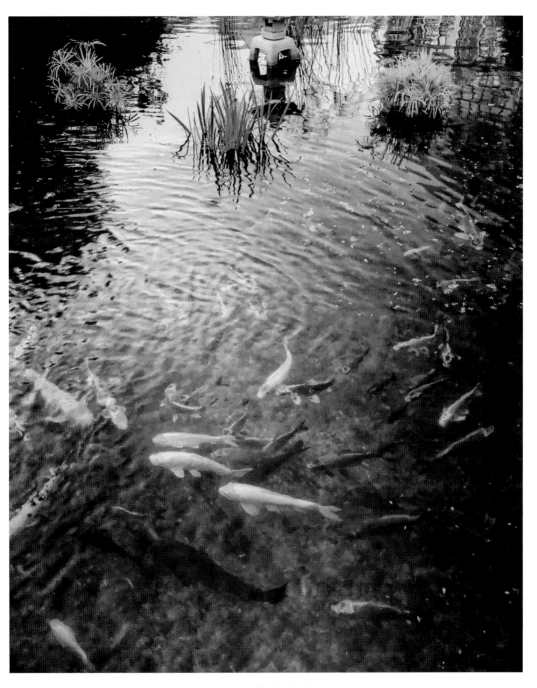

Shimmering koi spin circles in the pond next to the Belle Isle Conservatory.

2

About the Cars

As the sleek, vintage mustang purred down Woodward, people lining the road craned their heads and the clicks of cameras could be heard. Parking lots along the boulevard were filled with vehicles illustrating the history of one of the most cherished items in Detroit: the automobile. Detroit, aka the Motor City, is synonymous with vintage automobiles. Detroit is the life blood of the automotive industry.

Detroit's long love with cars started in 1896 when Henry Ford test drove his vehicle down the streets. This heralded in a glowing era for the Motor City, with Olds Motor Works opening in 1899, manufacturing the beloved Oldsmobile followed by the Ford Motor Company in 1903. The Packard Company landed in Detroit and the remains of its 3,500,000-square-foot factory can still be seen from I-94, a skeleton of what used to be a massive plant supplying hundreds of jobs. In 1908, General Motors came followed by Chrysler in 1925. General Motors is still firmly rooted in the Motor City and operates out of the Renaissance Center, which heralded in the rebirth of Detroit, with three modern glass towers perched next to the Detroit riverfront, and the company's newest location at the old Central Train station, a classic example of the wonderful architecture that was created in the city. Detroit was the hub of the automotive industry with the Big Three firmly rooted in its history.

This huge creation of thousands of jobs caused a mass migration to Detroit and its population peaked in the 1950s with over two million residents. This love of the automobile has continued to flow through the veins of the people of Detroit and every year there are events highlighting this passion.

One of the biggest is Autorama, an event that is housed in Huntington Place at 1 Washington Blvd. Over 140,000 people come to display their custom vehicles at this famous event and gawk at all the amazing cars bathed in the center's lights.

Autorama is a joyful event that will satisfy any car, truck, or motorcycle lovers discerning pallet.

One could not fail to mention the North American Auto show, a massive dealer exposition at the beautiful TCF hall, located in the downtown area, where automotive companies showcase their upcoming vehicles for the future and highlight their innovative technologies.

Though it is the most massive, other car meets pop up throughout the spring and summer and a quick Google search can find them. One of them, hosted by EMMETT Car Meet, hit the riverfront in 2021 and was sponsored by the Detroit police department. Hundreds of cars were displayed, and their sleek metal formed a shiny patchwork that complimented the towering Renaissance Center. This passion for cars has also created a plethora of local car shops, ready to help with vintage parts, authentic paint, and advice how best to fix up a person's mechanical baby.

For a car lover, the is no greater city than the Motor City, a place rich in automotive history and which today still employs millions of workers. Here, if you love cars, you can find an auto meet that will excite and inspire you.

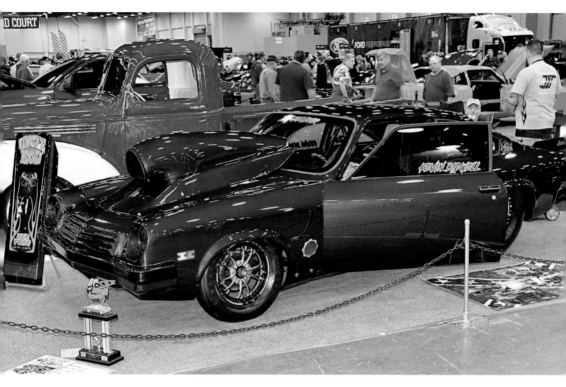

People peruse the polished, sleek vehicles at Autorama.

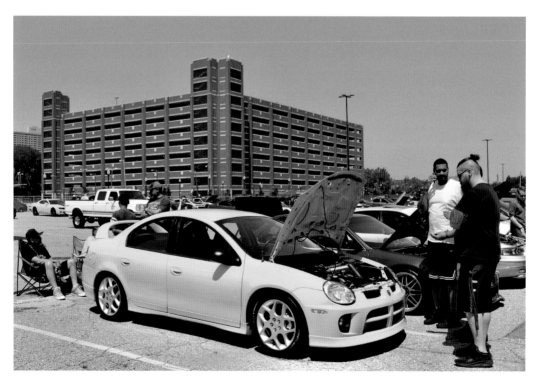

People discussing a sleek ride at the EMMETT car meet.

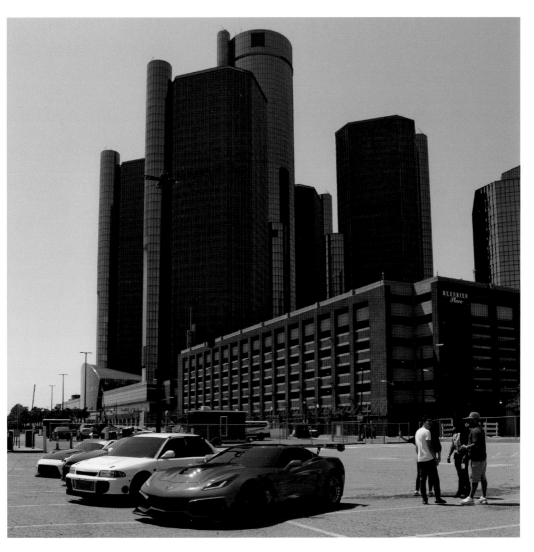

The EMMETT car meet guarded over by the Renaissance Center.

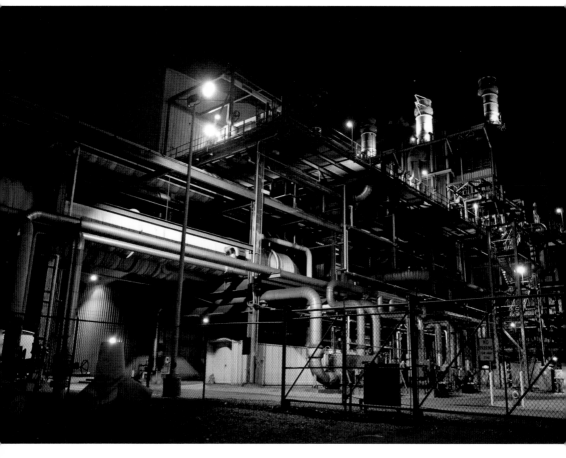

The Ford River Rouge Complex at night, a factory that helped build Detroit.

3

Classic Locations

For thirty-eight years, the African World Festival, now resting in the shadow of the Charles H. Wright Museum of African American History, on 315 E Warren Ave, has taken place in Detroit. Attracting over 100,000 visitors a year, this ethnic festival is the only one of its kind nationwide and one of the largest in Detroit. Spread over three days, the festival offers music on multiple stages, delicious ethnic enticements, and colorful vendors displaying everything from art to rainbow apparel. There is something for all ages, from a youth/family area with storytellers to a runaway fashion show. The festival is a hallmark of Detroit that wraps around the museum and provides fun for everyone.

The John King Book Store, on 901 West Lafayette Blvd, was established in 1965 in Dearborn, Michigan, and moved to Detroit in 1971. In 1983, King purchased an abandoned glove factory to house the store which currently holds over a million books. To walk into the store is like taking a walk back in time and leaving the digital age behind while immersing yourself in row upon row of printed tomes illuminated by the splices of light cutting through the heavy glass factory windows. Interesting merchandise, such as antique statues and faded comics, nestle among the books, and the stairwells are decorated with artwork from local artists and old prints. Glass cases bathed in soft light highlight antiques from eras past and the smell of forgotten memories permeates every level. The store harkens to crime movies of the past where the protagonist yanks a volume off the shelf and flips through its pages to solve a mystery. The John King Book Store is a delight for anyone who loves the feel and smell of old stories.

Founded in 1930 by Cross Moceri and Peter Cipriano, Better Made Potato Chips, located at 10148 Gratiot Ave, was one of thirty-one chip factories in Detroit. Today,

Better Made is the only company left. These salty, flavorful snacks can be found throughout stores in Detroit. If you need a drink to go with your chips, then try another Detroit classic, Faygo soda, made by Faygo Beverages Inc, a company with deep roots in Detroit and established in 1907. Its headquarters is just down the street from Better Made and has a colorful soda can propped next to its building at 3579 Gratiot Ave. Faygo soda was soon known as "pop" for the way the bottles popped when opened. Faygo inspired a famous song "Faygo Boat Song" that topped #3 on the charts in the 1960s, its video which was filmed on the Boblo Boat, a vessel that took Detroiters to an amusement park on Boblo Island in the Detroit River. Faygo Song:

Comic books and rubber bands
Climb into the treetop
Falling down and holding hands
Tricycles and Red pop
Pony rides and Sunday nights
Roller skates and snowball fights
Climbin' through the window
Remember when you were a kid?
Well, part of you still is
And that's why we make Faygo
Faygo remembers

(If you ever heard this, I am sure the melody is now playing in your mind.)

Another notorious food that Detroit is known for is the Coney Island hot dog, a frankfurter smothered in onions, cheese, and chili on a soft, white bun. American Coney Island, at 114 W. Lafayette Boulevard, steals the honors for being the first Coney Island restaurant in Michigan. With its bold, retro blue and crimson awning and black-and-white linoleum floor, you feel like you have stepped into the past when you visit. Enjoy the classic coney cuisine with a side of crispy, golden fries while watching people stroll down the boulevard.

The Two-Way Inn is the oldest bar in Detroit, built in 1876, located at 17897 Mt. Elliot St, and affectionately known as a "fine dive." Established by Colonel Philetus Norris, the building wore many cloaks, from a general store to a jail, to a possible brothel, to a dentist housed with a saloon. The story goes that the inn got its name from the two ways in and out of the bar in case police came looking for you. With its polished wood floors and Grandpa Malak's hunting trophies perched on the wall, the words that come to mind are warm, earthy, and laid back. A large brass bell

hangs in the bar, taunting you to ring it, but beware, if you ring it, you must buy everyone in the bar a round. While enjoying your brew, ask about the quarter toss tradition and the wishes sent to the Bar Gods.

The Detroit Public Library Main, located at 5201 Woodward, squats across the avenue from Wayne State University and is a part of the second largest library system in the United States. Designed by Cass Gilbert and dedicated in 1921, the library walls are constructed of Vermont marble and trimmed with Italian marble in the Italian Renaissance style. The theme is continued on the interior of the building with the entranceway's ornate ceiling with antique lights. Hung artwork can be seen throughout the library and includes such works as a mural of the history of Detroit transportation by John Stephens Coppin along with a mural from 1921 by Gari Melchers highlighting Detroit's history. All this can be appreciated while strolling the peaceful wings of the library while inhaling the smell of old books.

The Ford Wyoming Drive-In, 10400 Ford Rd, on the Dearborn/Detroit border, established over seventy years ago, used to hail as the largest drive-in in the United States. With Retro architecture from the 1940s, in loud crimson and blue colors, the drive-in hosts five outdoor screens and a concession booth. This is the perfect place to grab the family, some popcorn, and blankets, and nestle down to the nostalgia of watching a movie at the drive-in.

The Redford Theater, at 17360 Lahser, opened in 1928, with its faded, historic, neon marquee, disguises what splendor lies inside. The theater contains a three-story foyer with curved staircases and splashes of gold, crimson, and orange on oriental décor in its auditorium. The theater survived the ravages of time and has been restored to its former glory by a group of dedicated volunteers and now sports a 20' x 40' screen to amuse movie goers.

Louisiana Creole Gumbo, at 2051 Gratiot Avenue, established in 1970, is a hole-in-the-wall restaurant that is a local favorite for authentic Cajun food from old family recipes. Grab some savory seafood gumbo, a delicious shrimp poboy, or some spicy jambalaya after checking out the Eastern market or cruising down Gratiot.

Wayne State University, at 42 West Warren, was founded in 1968 and sprawls across 230 acres with over 100 buildings. With its historic architecture, it is the perfect place to go for a peaceful stroll and watch the sunset over the skyline of Detroit. One of the most notable architects was world renown Minuro Yamasaki, who designed the College of Education Building, the McGregor Memorial Conference Center, the Helen L. DeRoy Auditorium, and the Prentis Building. Focusing on shadow and light, ornamentation, and classic elements such as Gothic arches, Yamasaki created intricate, eye appealing structures that captivate visitors every year.

The architect who was one of the most critical in shaping the skyline of Detroit

was Albert Kahn, who designed multiple skyscrapers, office buildings and mansions dotting the metro area. Some notable structures include the Ford River Rouge Auto Plant, the Fisher Building, the Detroit Free Press Building, the Packard Automotive Plant, the Edsel and Eleanor Ford House, the National Theater, and the Bonstelle Theater. One of his structures, the Detroit Free Press Building, at 321 W. Lafayette, was constructed in 1924 and held one of the largest Detroit newspapers for years. With its Art Deco style and limestone façade carved with bas-relief figures symbolizing commerce, the building is a testament to the beautiful architecture Kahn brought to the city. The Press/321 is now under renovation for apartments.

Another extraordinary building to visit in Detroit is the Guardian Building on 500 Griswold and built during the roaring twenties. Its architect, Wirt C. Rowland, got inspiration from the Native Americans and Aztecs to create a bold, colorful brick and terracotta structure whose splendid details are continued from its exterior to its interior. Shops are located inside, and while browsing what they have to offer, you can take in the arched ceilings highlighted with brilliant tiles and painted murals, crafted by over forty artists.

The Russell Industrial Center, at 1600 Clay Street, is another creation of the architect Albert Kahn. The 2.2-million-square-foot, seven-building complex was once used by the Murray Body Corporation, a supplier to Ford but in 2003 was converted into studio space and hosts a unique group of artists, businesses, and creative professionals. One charming store that calls the Russell home is Detroit Urban Artifacts in Room 119 with numerous antique and vintage pieces collected from all over the city. With its inviting entrance, you can stroll back into Detroit's history while checking out all the treasures. One of the many bands that calls the Russell home is Hairy Queen, on the fourth floor in room 420, a punk band made up of musicians have been a part of the scene for decades. On Thursday night, you can hear the group practicing in their studio with walls festooned in old records and vintage posters.

Signal Return is another hidden treasure in Detroit, nestled next to the Eastern Market at 1345 Division. Signal is a community letterpress shop where wood and metal type line the walls watched over by platen and sign presses. A gift shop contains the handmade, unique prints along with an opportunity to make your own creations in hands-on art workshops.

The Detroit Renaissance Center at 400 Renaissance Center Drive (which construction began in 1971), with its three shimmering glass towers, is one of the most recognizable structures on the city's skyline. Its hotel tower, now part of the Marriott, is still the tallest building in Michigan. In 1996, the "RenCen" was purchased by General Motors and became the company's headquarters. The complex is so

large, with 14-acres of offices, restaurants, and shops, that it has its own zip code.

Greektown, located on Monroe Street, between Brush and St. Antoine Streets, is a vibrant cultural center with delicious ethnic food, the glittering Greektown casino, and historic Greek décor. You can stroll the street under sparkly white lights while inhaling the heavenly aromas of moussaka (eggplant and beef), dolmadakia (stuffed grape leaves), and saganaki, a flaming Greek cheese that when lit by the servers is accompanied by an "Opa!" You can the head on indoors, into the multistoried 1850s-era building with its tiers of shops bathed in golden light, hovering over the entrance of the casino.

Z lot, located from the corner of East Grand River and Broadway to the corner of Gratiot and Library, is a ten-story parking garage filled with murals from artists around the world. It is a popular site for selfies and portraits featuring the Detroit skyline, or vibrant, bold artwork in the background. Residing between the two wings of Z lot is a cobblestone, art-strewn alley, also known the Belt, which hosts establishments with food, spirits, and music.

The Elmwood Cemetery, at 1200 Elmwood St., is Detroit's oldest non-denominational church, encompassing 86 acres. Many notable people of history are buried here, including George DeBaptiste, who worked with Frederick Douglas during the abolitionist movement; Margaret Mather, a great Shakespearean actress of the nineteenth century; Douglass Houghton, Michigan's first state geologist; along with governors, mayors, and veterans of all wars. Running through the property is Bloody Run Creek, named for the Native American massacre of Captain Dalzell. Stately groves of trees wreath historic buildings and an 1856 limestone chapel, allowing you to take a walk into history in silence, away from the hustle of the city.

If you want a taste of Detroit, there is no better place than the Eastern Market at 2934 Russell St. Established over 150 years ago, the market is a wonderful place to savor the cuisine from the local restaurants, sink your teeth into sugary confections from the Milano Bakery, inhale the scents of colorful produce and vibrant flowers, or attend cultural events that promote local artists and businesses. As you stroll through the market sheds, with the bustling crowds, gaze upon the numerous murals splashed upon the brick walls. The market is open year-round on Saturdays and in the summer, on the weekends and Tuesday. Many of the businesses surrounding the market are open seven days a week where the locals buy their groceries or have a snack. If you love gardening, in May, the market hosts flower day, where you can pick up flats and pots of every bloom you desire.

The Buffalo Soldiers Heritage Association houses their horses at 21800 Joy Road at the Buffalo Soldiers Heritage Center abutting Rouge Park. The Buffalo Soldiers were African Americans who were former slaves, freemen, and black Civil War

soldiers who helped build the west by escorting settlers, railroad crews, and cattle herds while constructing infrastructure for the settlements. You can visit the center to see reenactments, pet the horses, and hear about the harrowing tales of these great soldiers.

Mexican Town, located at Bagley and 24th, sprawls down Vernor Highway around Waterman Street. It is a down-to-earth neighborhood with Hispanic roots extending from the 1920s. Here you can get a Latino infusion of culture and art along with traditional Mexican cuisine, from tacos to tamales. If you have a sweet tooth, the area hosts many bakeries who serve up divine concoctions such as tres leches cake, an ultra-fluffy sponge cake made with three milks and topped with whipped cream and cinnamon. Mexican town also has many beautiful murals adorning its buildings from famous Latino artists for your viewing pleasure.

Opened in 2021, Mom's Spaghetti, located at 2131 Woodward Avenue, is the famous rapper Eminem's newest creation. The name of the business comes from his hit, 8 Mile Road, a well-known road that serves as the border between Detroit and the northern suburbs. Serving homemade cooking, the restaurant has an earthy, retro style. You can grab a plate of spaghetti while gazing out at Woodward and the glimmer of the city lights in downtown.

TCF Center, at 1 Washington Boulevard, is the seventeenth largest convention center in the nation, and is host to all kinds of exciting events year-round. Some of the most prominent are Autorama, the North American International Auto Show, and Youmacon. When you are in town, check out what is happening there.

Pewabic Pottery, located at 10125 E. Jefferson Avenue, is a National Historic Landmark founded in 1903 which is a haven for artists who specialize in pottery. The business attracts people from around the world and is famous for its ceramic tiles that can be found in historic buildings and homes around the city. You can visit the organization and walk through their gift shop and gallery while peeking at the artists' workshop and kilns.

If you want to take a walk in the wild, then head over to the DNR Outdoor Adventure Center at 1801 Atwater Street. Located in the historic Globe building, you are greeted by an elk and sturgeons as you walk through the entrance. Enjoy a waterfall, climb a hanging bridge, step into a fishing boat, or see the native fish swimming in the aquarium. The Adventure Center is a place you can explore the great outdoors while not stepping outside the city.

If the spirit of Detroit is starting to permeate your being, there is no better place to show your Detroit pride than Pure Detroit, where its main store is located at 3011 West Grand Boulevard. For over twenty years, Pure Detroit has sold merchandise that is unique to the city, such as Faygo t-shirts and purses made from seat belts

to Pewabic Pottery tiles. After shopping for some classic Detroit swag, you can admire the iconic architecture of the Fisher Building, where the store is nestled.

The Dakota Inn Rathskeller, an authentic German bar, located at 17324 John R Street, was founded in 1933 by Karl Kurz, a German immigrant, and is still run by the same family after eighty-eight years. When you walk into the bar, you are transported back to "old world" Germany, and are wrapped in warm, luminous lights illuminating polished, dark wood walls and antiques from forgotten days. The bar mimics a neighborhood pub's atmosphere, with sing-alongs and a Schnitzelbank, a polished woodworker's bench for seating the singers. The bar is a perfect place to enjoy a lively crowd and drink a foamy German beer.

Harpos, at 14238 Harper Avenue, was built in 1939 as a movie theater that has since been transformed into one of Detroit's oldest musical venues. Over the decades, notable bands have jammed on its stage, including Ted Nugent, Godsmack, Iron Maiden, Insane Clown Posse, and Snoop Dogg. With its intimate atmosphere, allowing for performers to mingle with their fans after the show, Harpos is a go to for live music and for an infusion of classic city culture and history.

The Schvitz Detroit, at 8295 Oakland Avenue, is the only historic bathhouse in the city. Built in 1930 with Russian Jewish influences and a gathering spot of the Purple Gang, a criminal mob of bootleggers during Prohibition, the bath house has since been renovated into a place of relaxation and healing. With its warm wooden panels, intricate plaster ceilings, and soft lighting, the house sports a pool and steam room to detoxify your body and sooth your sore muscles. After a massage, you can enjoy one of the house's famous savory steak dinners.

The Marble Bar, at 1501 Holden Street, is an intimate, funky bar created in a former bank. With twinkling lights and mannequins striking the poise, the place is noted for its experimental music and its leanings toward techno. The bar welcomes everyone and is a great place to hop on the dance floor during funk night. If you want to grab a drink and hear the latest musical creations of the city, be sure to pop in.

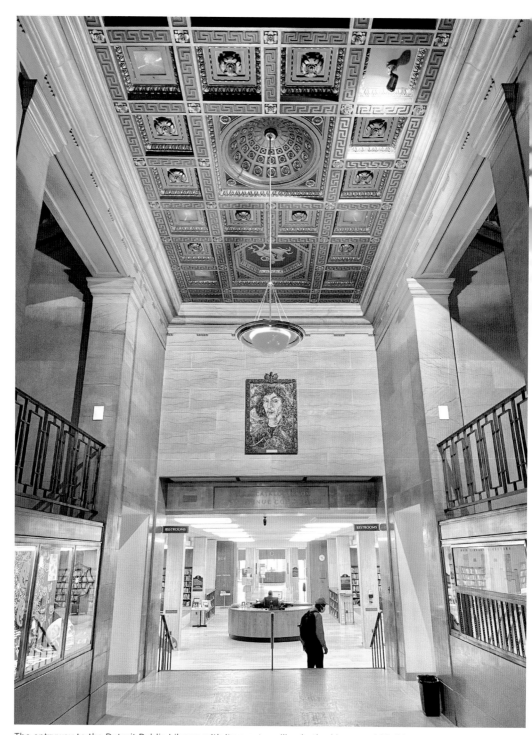

The entryway to the Detroit Public Library with its ornate ceiling bathed in emerald light.

The exterior of the Detroit Public Library.

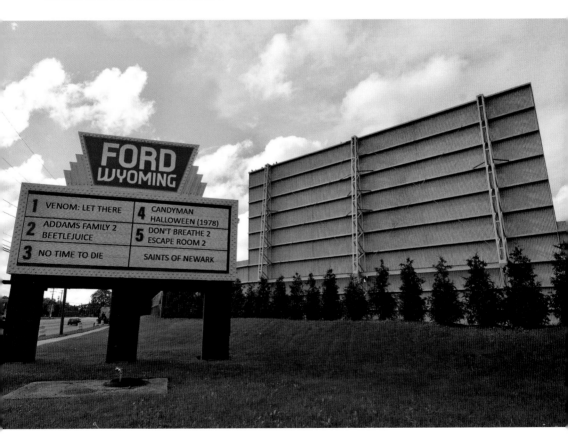

The marquee to the Ford Wyoming Drive-In showing the latest movies.

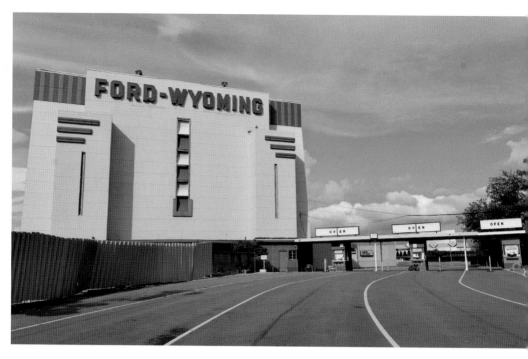

The retro Ford Wyoming Drive-In entrance with its ticket booths.

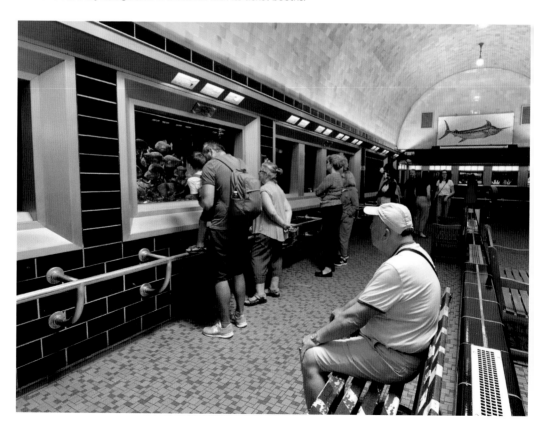

An older man watches the antics of a child with his father at the Belle Isle Aquarium.

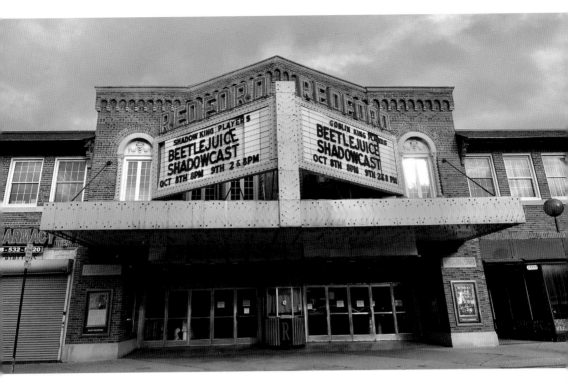

The historic marquee of the Redford Theater.

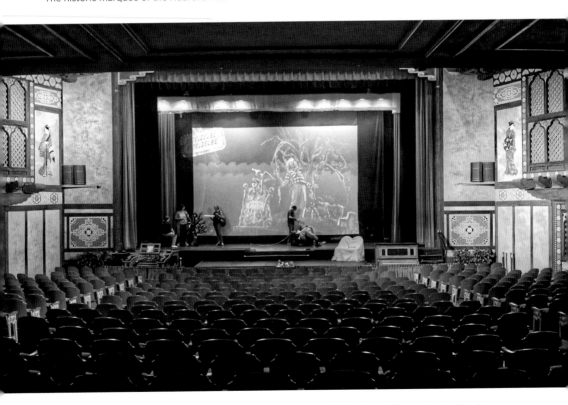

Inside the Redford Theater where staff are prepping for a special showing of the movie *Beetlejuice*.

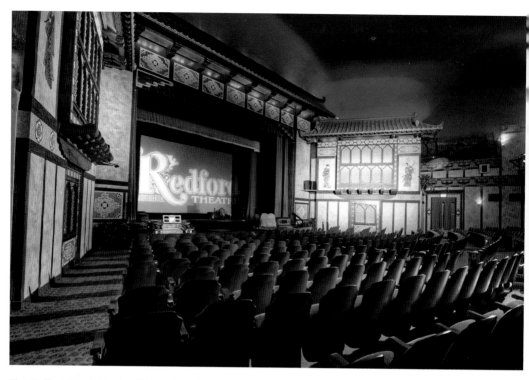

The Redford Theater's splendid interior with an oriental-style motif.

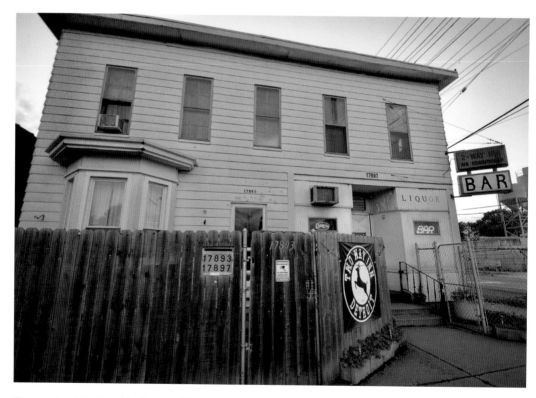

The exterior of the Two Way Inn, the oldest bar in Detroit.

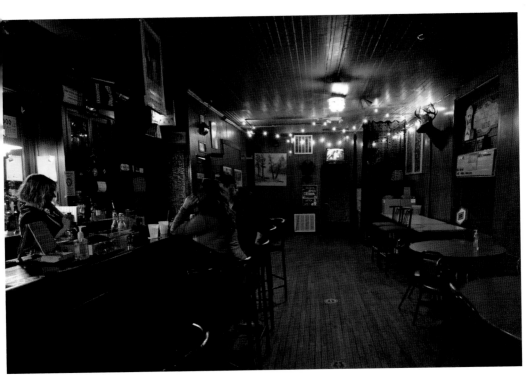

The Two Way Inn's interior has original wood and fixtures from the 1800s.

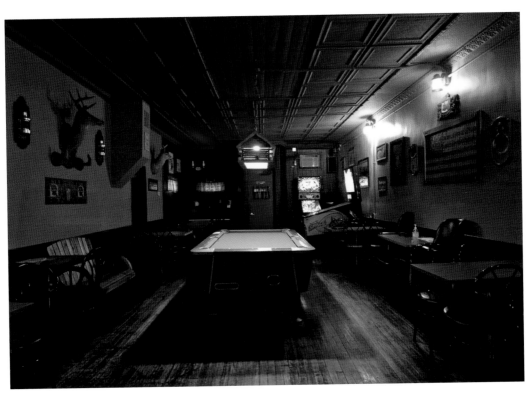

Two classic pinball machines are found amongst the many pieces of memorabilia found at the Two Way Inn.

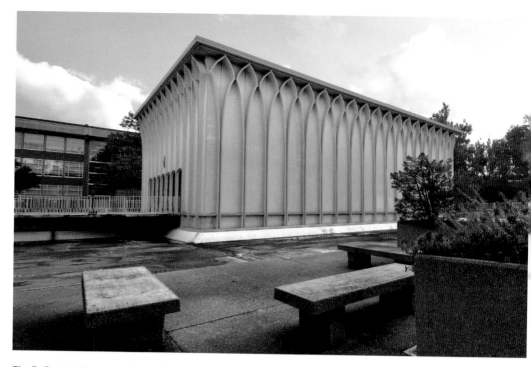

The DeRoy Auditorium on Wayne State University's campus with the renowned Yamasaki style with its play on light and ornamentation.

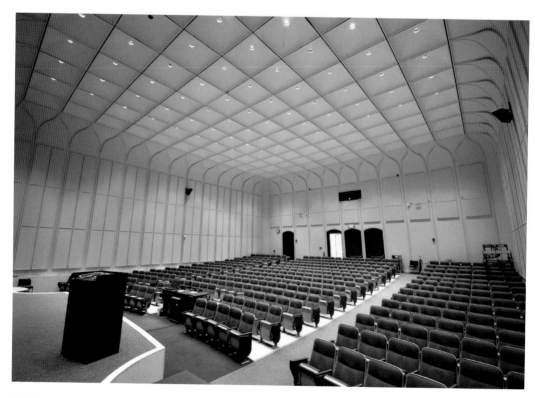

The interior of DeRoy Auditorium with Yamasaki's signature Gothic arches.

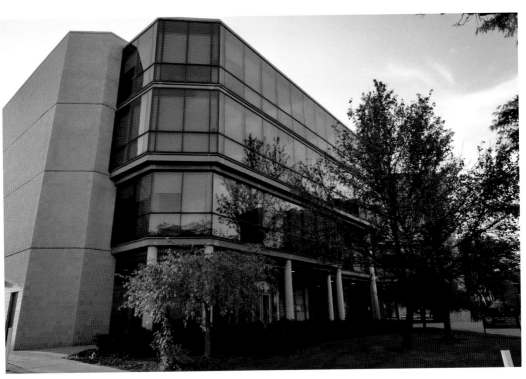

The exterior of the Kresge Purdy library, another example of the beautiful architecture found on the campus.

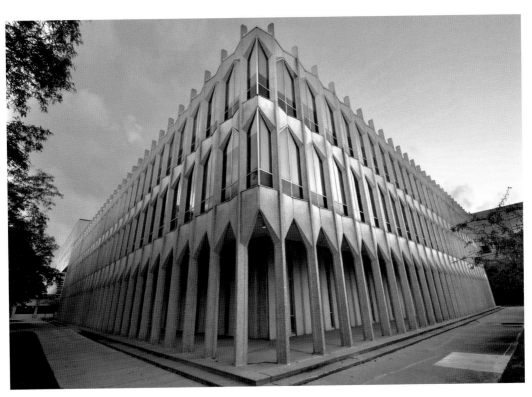

The exterior of the College of Education Building with its narrow, pointed windows.

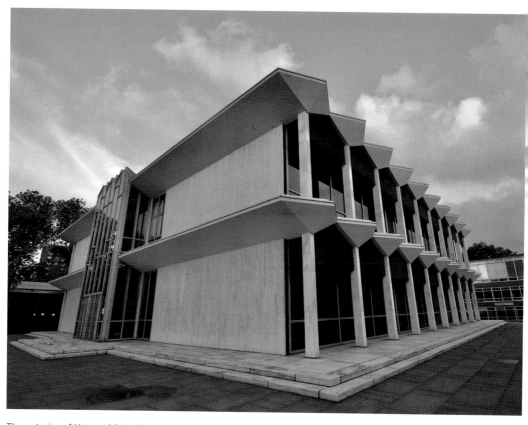

The exterior of Yamasaki's McGregor Memorial Conference Center.

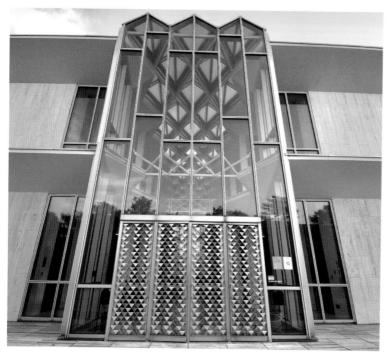

The entranceway of the McGregor center with its door festooned in metal triangles and highlighted by the azure glass above.

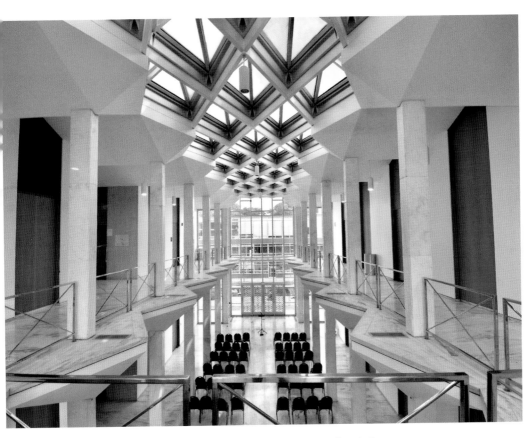

The interior of McGregor with its jagged edged floors and triangular windows.

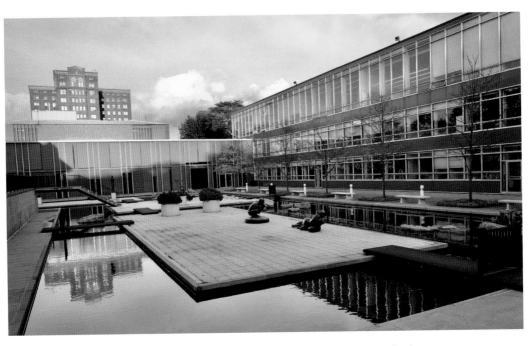

The reflecting pool next to McGregor surrounded by the Community Arts Auditorium.

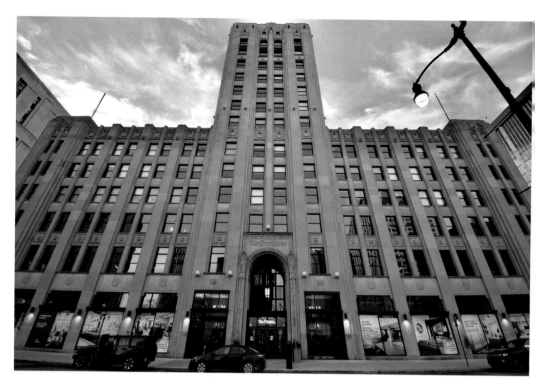

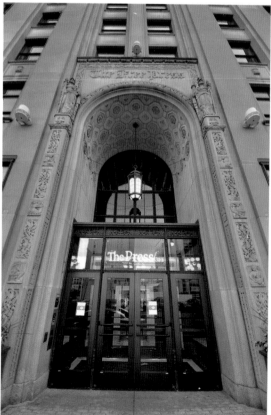

Above: The Detroit Free Press building illuminates the classic Art Deco style Kahn infused into his structures.

Left: Though being converted to apartments, the developers kept the beautiful facade of the Detroit Free Press building.

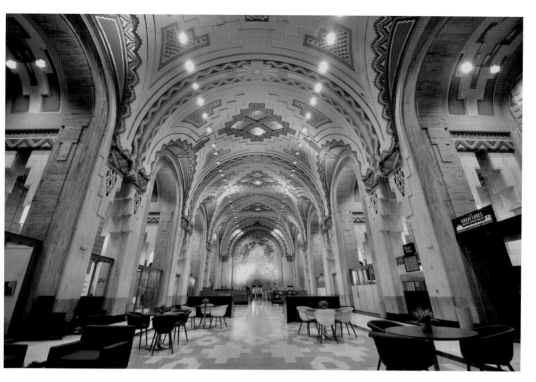

The interior of the Guardian Building pays tribute to the roaring twenties with its splashes of bold color and Art Deco style.

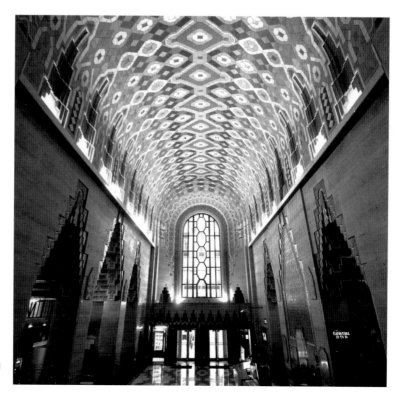

The atrium of the Guardian Building is painted with colorful tiles.

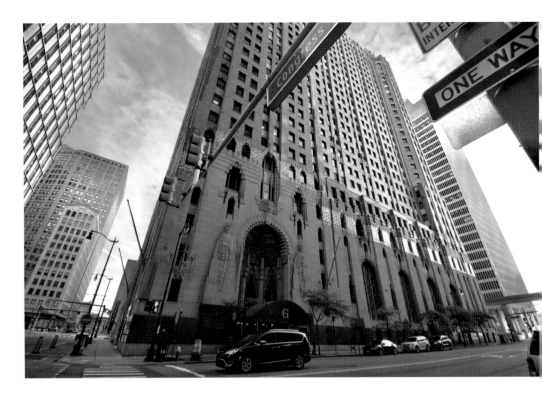

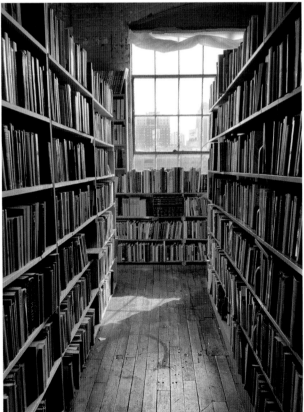

Above: Rowland did not neglect the exterior of the Guardian Building with its imposing tangerine brick and carved terracotta.

Left: The smell of old books permeates the air at the John King Bookstore.

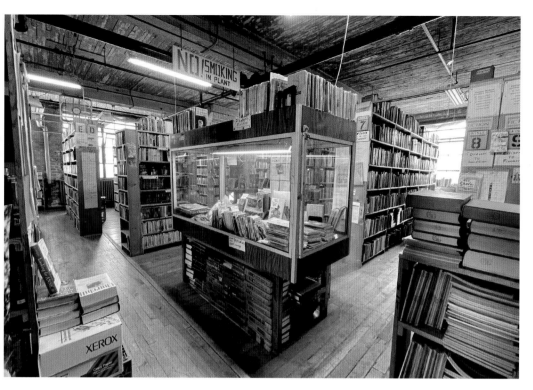

Cases of rare books and vintage keepsakes are bathed in a warm glow surrounded by rows and rows of novels at the John King Bookstore.

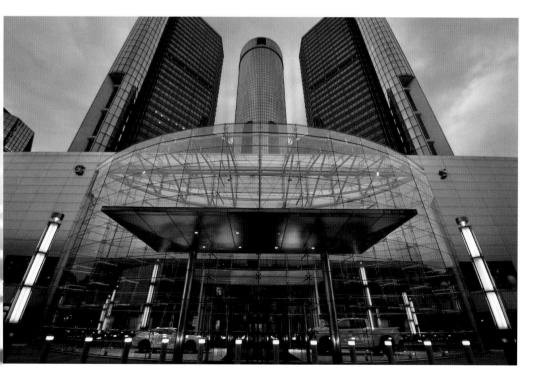

The beautiful, arched glass entrance to the Renaissance Center.

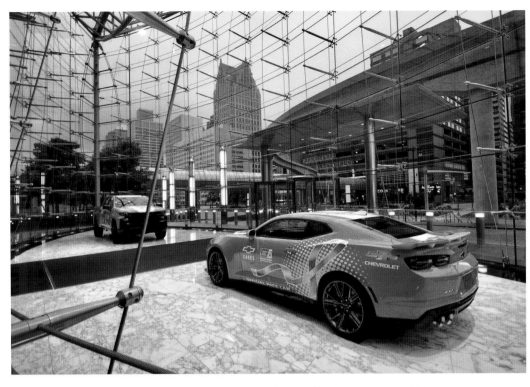

A view of downtown through General Motor's automotive display with its hot magenta vehicles.

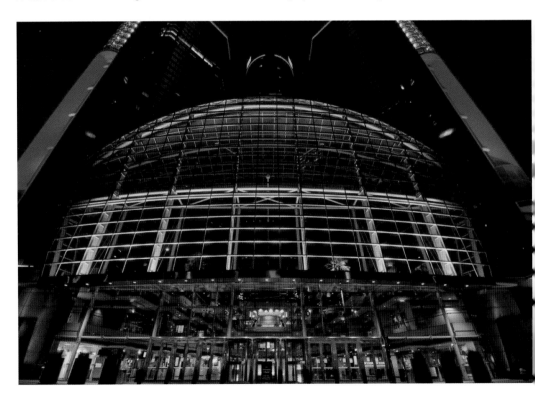

The Renaissance Center aglow at night.

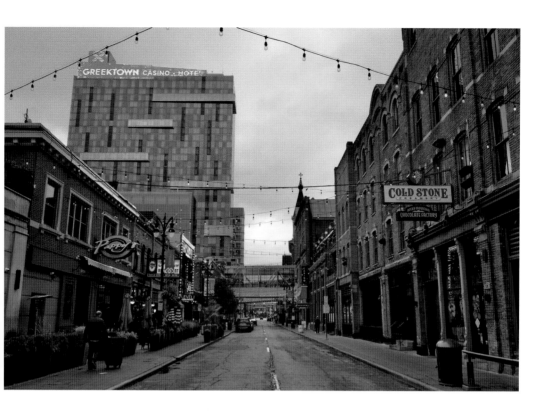

Above: Monroe Street, headed into Greektown, under twinkling lights at dawn.

Right: A converted 1850s structure with its golden light chandeliers, skylights, and shops.

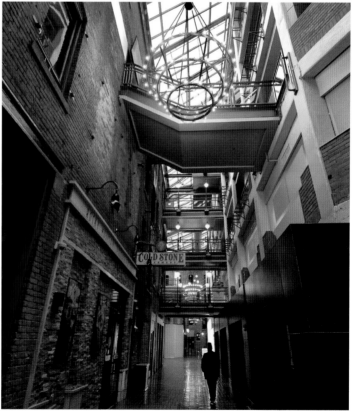

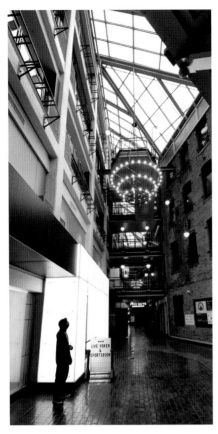

Left: The entrance to the Greektown Casino, framed in by white, glowing, rectangles.

Below: Guys shoot some hoops on Monroe Midway's half courts.

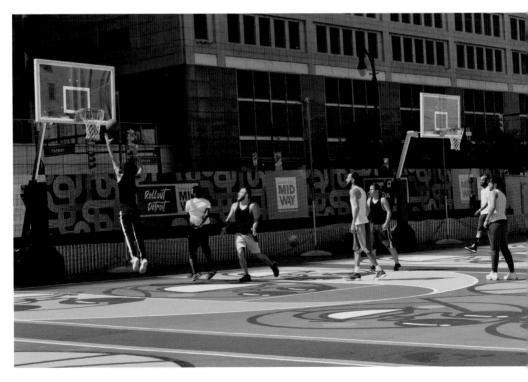

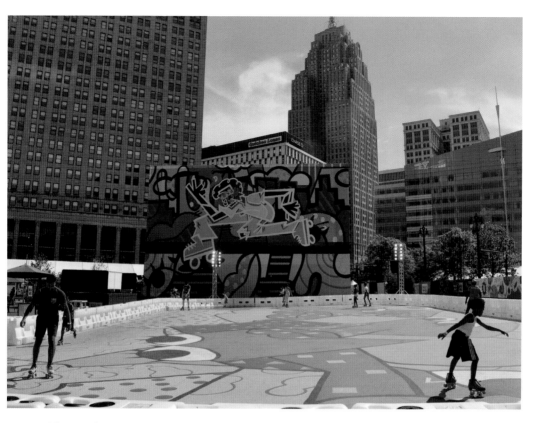

Kids enjoy the outdoors while rolling around Monroe Midway's roller rink.

Photographers chat on the roof of the Z lot.

A view from the roof of the Z lot.

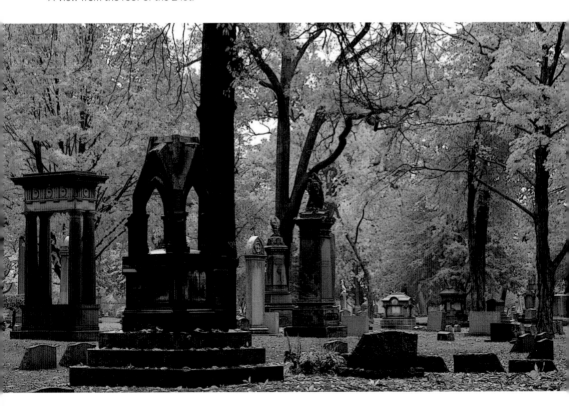

Elmwood Cemetery on Halloween in the rain.

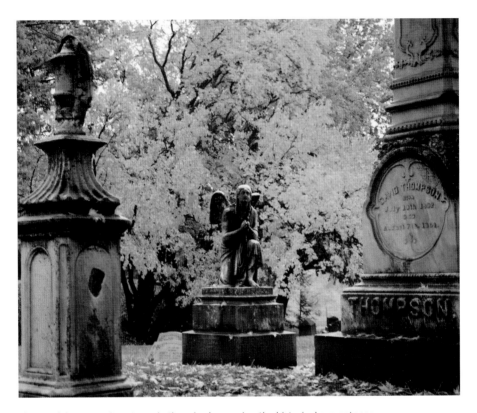

Elmwood Cemetery in autumn in the rain showcasing the historical gravestones.

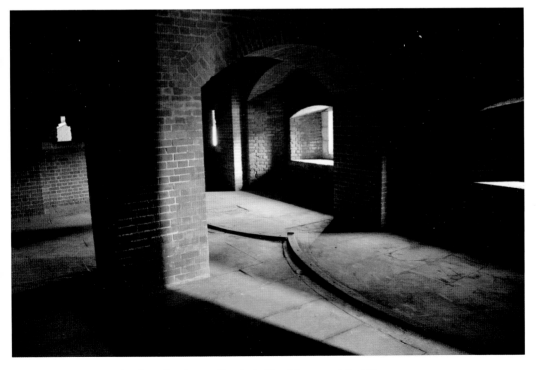

Flaking brick-red walls and arches are illuminated by dying rays at Fort Wayne.

One of the many beautiful murals that can be seen at the Eastern Market.

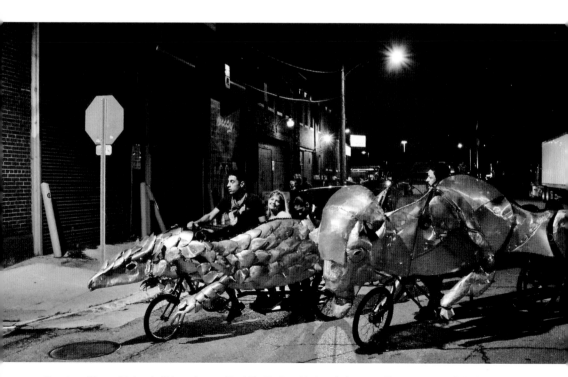

People getting a ride in a buffalo and pangolin at the Eastern Market during one of its events, Murals in the Market.

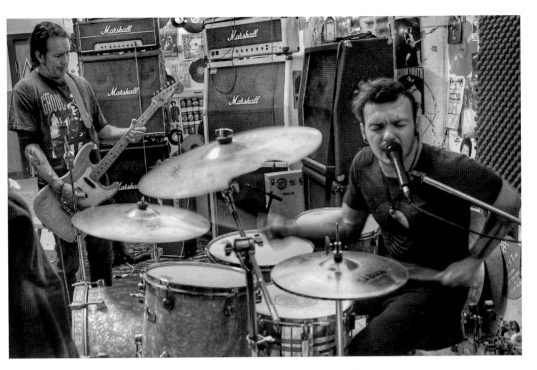

Hairy Queen, a punk rock band, practicing in their studio at the Russell Center.

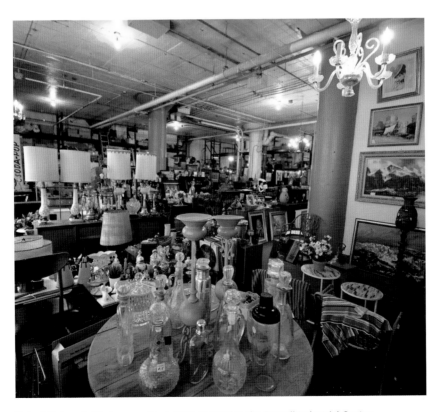

Detroit Urban Artifacts, an antique store, located in the Russell Industrial Center.

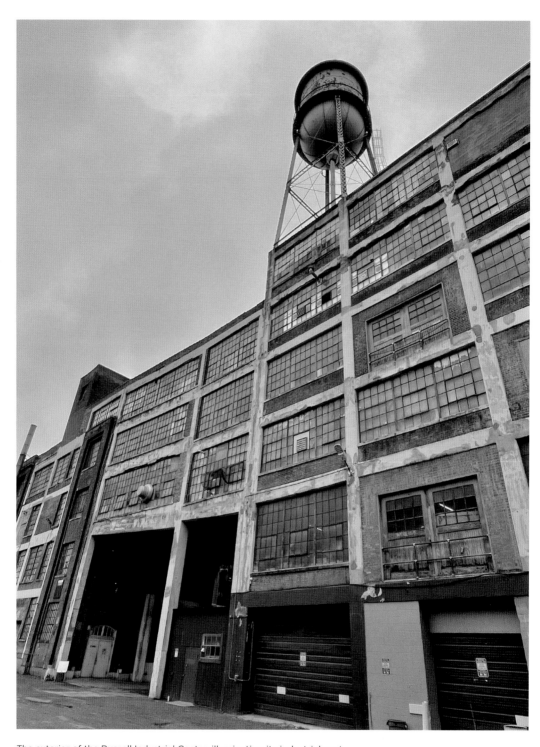

The exterior of the Russell Industrial Center, illuminating its industrial past.

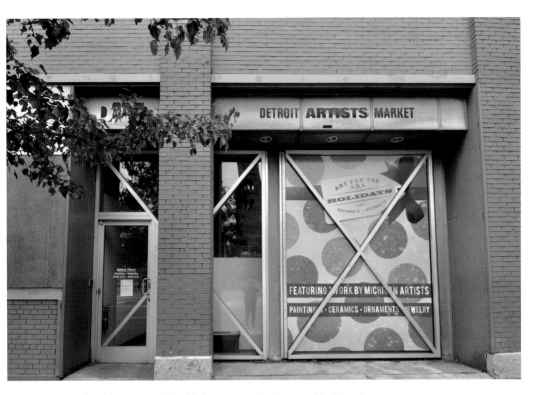

The facade of the Detroit Artist Market announcing its annual holiday show.

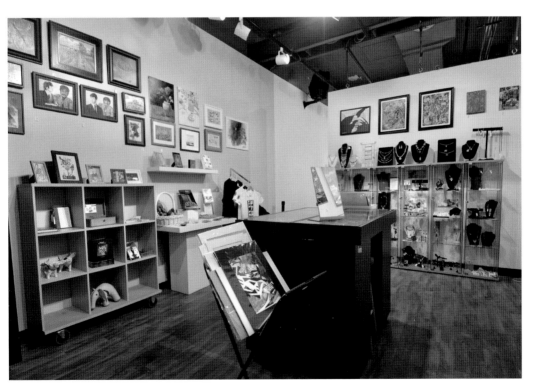

Detroit Artist Market's gift shop accentuating the works of local artists.

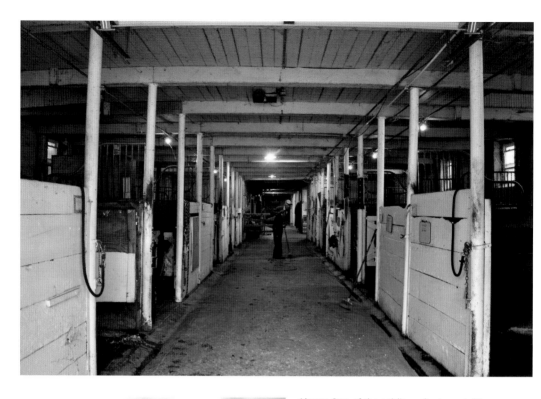

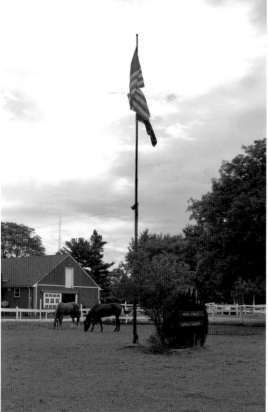

Above: One of the soldier volunteers, taking care of the horses, at the Buffalo Solider Heritage Center.

Left: The horses at the Buffalo Soldier Heritage Center, grazing peacefully under the American flag.

Hispanic restaurants dot Bagley Street in the neighborhood Mexican Town.

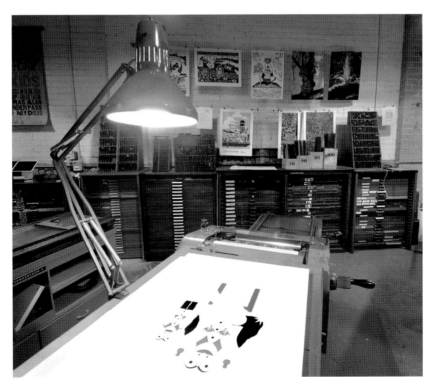

A poster in progress at the letterpress printing workshop of Signal Return.

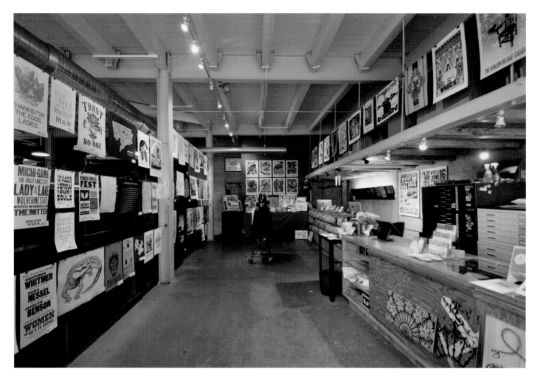

Eye-catching prints decorate the entranceway to Signal Return.

Mom's Spaghetti, Eminem's restaurant.

TCF Center with a gorgeous view of the Detroit River during Youmacon.

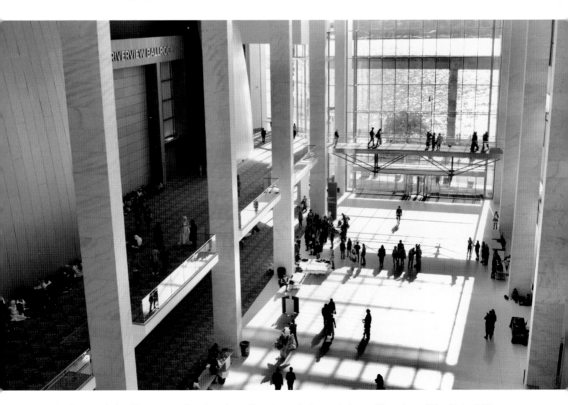

TCF Center during Youmacon showing the ceiling-to-wall glass window with a view of the Detroit River.

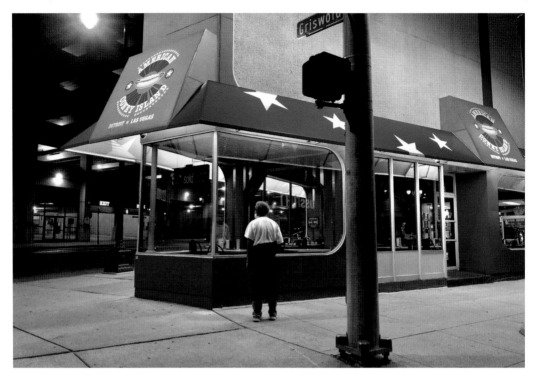

A passerby pauses to peer into American Coney Island.

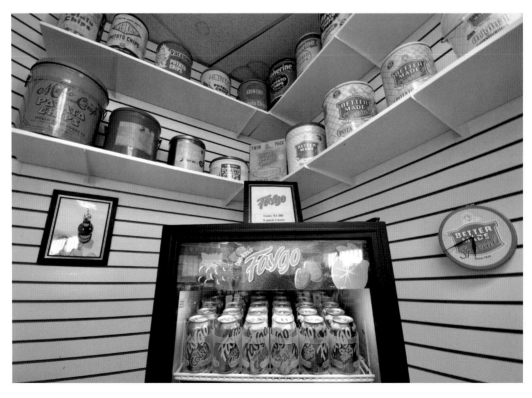

Two Detroit food favorites, Faygo soda pop and Better Made potato chips.

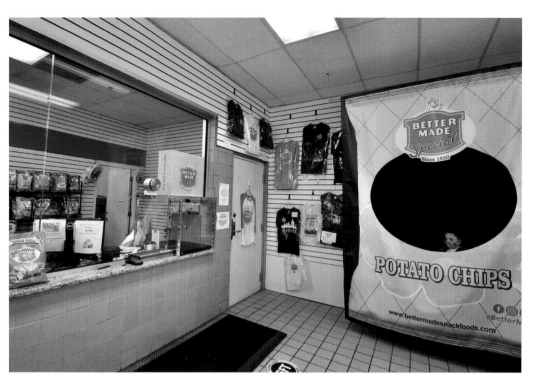

The gift shop at the Better Made factory.

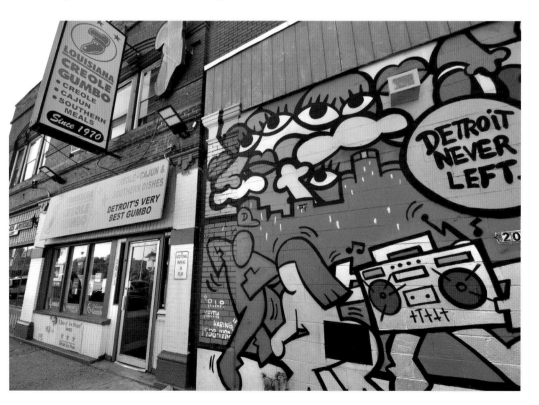

A mural splashed on the brick wall decorates the entrance way to Louisiana Creole Gumbo restaurant.

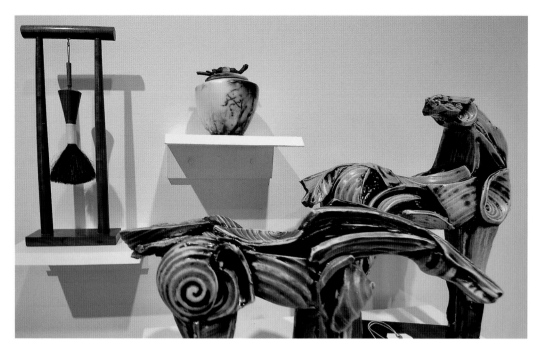

Beautiful works from the gallery at Pewabic Pottery.

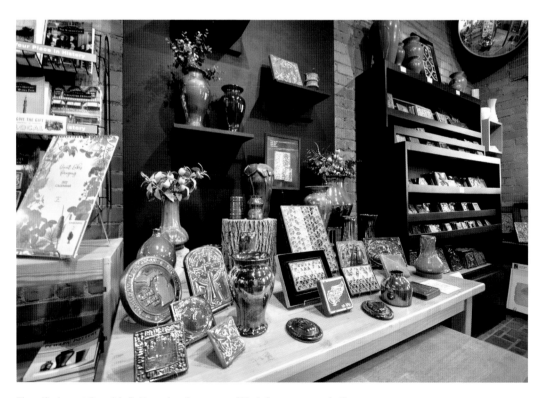

The gift shop at Pewabic Pottery showing some of their famous ceramic tiles.

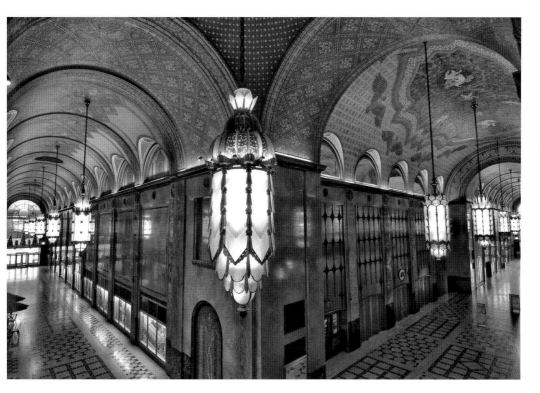

The radiant arches of the Fisher Building, which houses such shops as Pure Detroit.

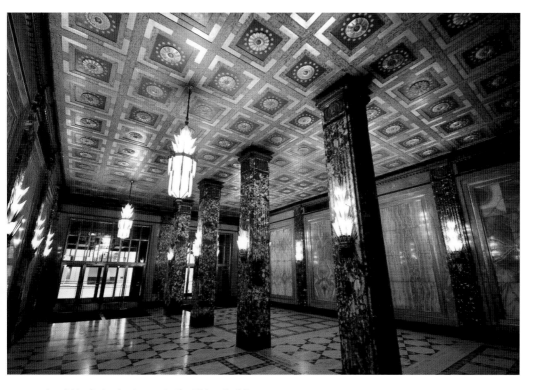

A gold bedecked entrance to the Fisher Building.

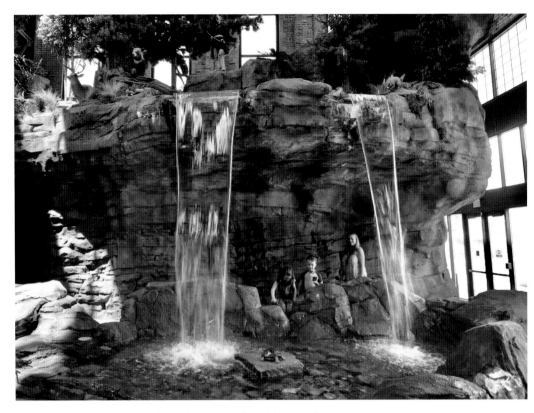

A waterfall tumbles onto the rocks at the DNR Outdoor Adventure Center.

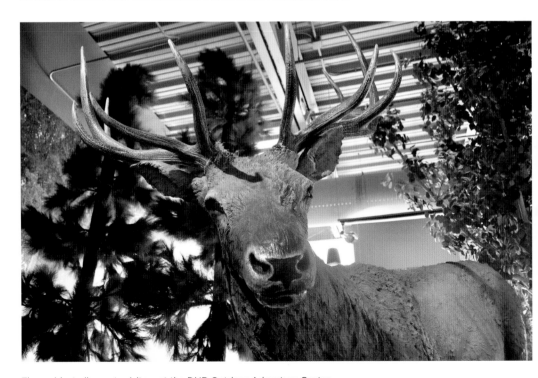

The resident elk greets visitors at the DNR Outdoor Adventure Center.

Outside the Charles H. Wright Museum of African American History during the African World Festival.

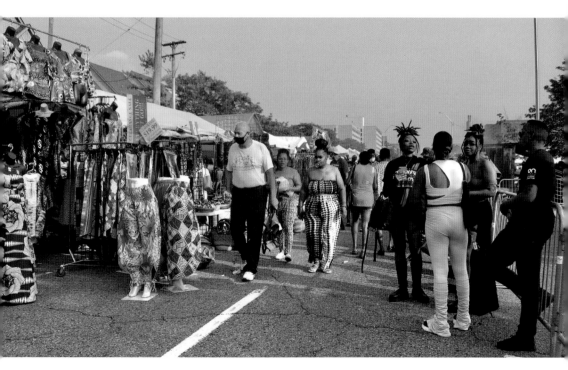

Vibrant, bold colors streak the street at the African World Festival.

4

For the Love of Fishing

Fishing is an incredibly popular sport in Detroit. If you stroll along any body of water in Detroit, you will find fisher people dotting the shores, poles in hand, while they chat with neighbors, a flick of their wrists sending hooks and lures below the crystal surface of the water. Sometimes, a pale gold sun illuminates their silhouettes in the morning, or a dying pink star streaks their figure with the last rays of light during the day. On cool fall days, the fisher folk, wrapped in blankets, their knit hats pulled tightly over the ears, send warm puffs of breath into the crisp air. In spring, an occasional colorful umbrella will hover over the fisher people while the braver ones will stand in the cool early rain with drops hitting the damp pavement, until soaked, and they will retreat to the vehicles while keeping an eye on their poles tied to railings. Occasionally a yell will break the stillness punctuated by a broad grin as one hauls a glittering wet fish onto dry ground.

Fishing is a hobby that anyone can partake in, no matter the age, and with miles of shoreline along the river, Detroit provides a perfect opportunity to enjoy it. Swimming in the river depths of up to 52 feet are sixty-five species of fish, from largemouth bass to northern pike to channel catfish to walleye, an angler favorite which can be caught year-round. Next time you are in Detroit, take a chance to drop your line.

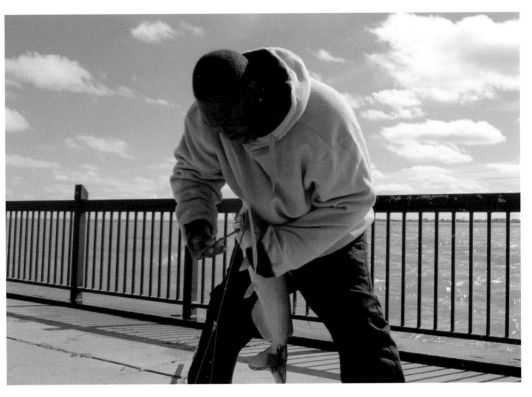

Fisherman unhooking his catfish on the Detroit River.

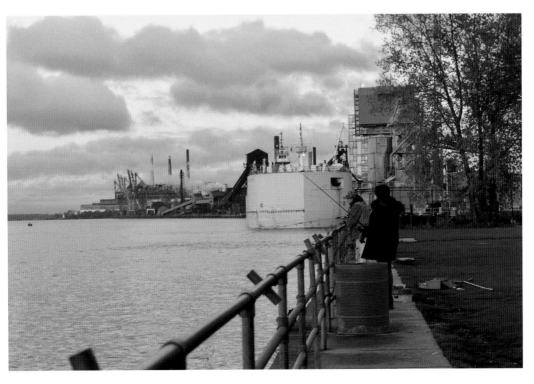

A couple fishing near the south end of Detroit.

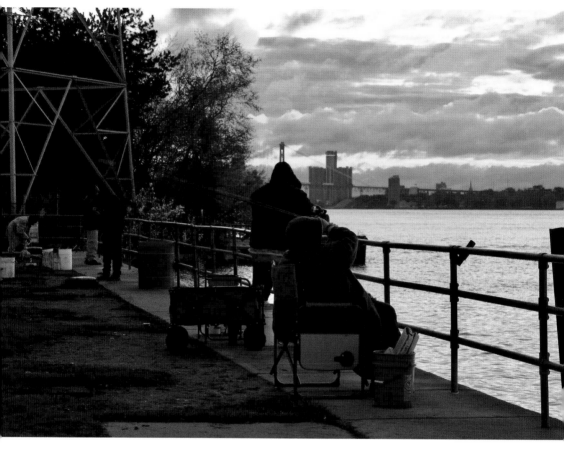

A group fishing at dawn with the Ambassador Bridge in the background.

5

Hidden Art

Hidden within Detroit are outdoor art installations by notable, gritty Detroit artists. The pieces are classic of Detroit—gritty, unusual, and obscured by the neighborhoods wrapped around them. Evolving over the decades, the works continuously change like the city and show the endurance of the artists and the residences who enjoy them.

Tucked here and there throughout Detroit are small art parks highlighting notable Detroit artists. Bordering the Lodge Freeway, M-10, is the City Sculpture Park at 955 W. Alexandrine highlighting the work of the famous Cass corridor artist, Robert Sestok. Cass Corridor is an eclectic neighborhood in Detroit that is continuously evolving and borders the prestigious Wayne State University. Including work that spans over thirty-five years, twelve sculptures brood in a grassy field surrounded by an iron fence. The twisted metal works, created from tons of steel, tower over people and some look almost human-like.

Nestled in the neighborhood of Hamtramck, a city that melds with Detroit and hosts a vibrate ethnic community of Arabic and Polish people, is a backyard filled with colorful creations alluding to an amusement park called the Hamtramck Disneyland. Created by a former Ukrainian immigrant who landed in the city decades ago, and located at 12087 Klinger in Hamtramck, Dmytro Szyla's folk art is a joy to behold. For five years, from 1992-1997, the artist added to his creation and crafted a display with a wooden airplane, dolls, and other objects that sprawl across the 30-foot backyard and onto the adjacent garages. The artist has since passed, but his work can be viewed from a back-alley road.

A much larger installation, occupying more than is a city block, is the Heidelberg Project at 3600 Heidelberg St in Detroit. Created in 1986 by Tyree Guyton, who used discarded materials to create his installation, the creation was in protest

of the the1967 riots, which led to the decline of the neighborhood. The artwork symbolized beauty in a place where many people had been afraid to walk. A theme throughout the outdoor exhibit is time, with clocks painted on the various sculptures and represent a time for a change. On the Dotty Wotty house, one of the largest pieces, the large colorful polka dots clinging to a white background symbolize the interconnectedness of all things. The Heidelberg Project continues to change and has attracted over 200,000 visitors.

The Detroit Artist Market at 4719 Woodward Avenue is the longest running nonprofit gallery in the Midwest. Adorning its inner walls are numerous contemporary creations by local artists for sale. Started in 1932, the market has been a place that connects the community to beautiful art through its store and year-round events and exhibits.

Located at the corner of Grand River Avenue and West Grand Boulevard and encompassing two city blocks, the Dabls Mbad African Bead Museum is an outdoor exhibit displaying over eighteen installations created by the artist Olayami Dabls, whose works celebrate his African heritage. The pieces incorporate a multitude of media and are resplendent in strokes of color and shards of mirrors. You can park on the side street next to a house that has been transformed into an eye-catching sculpture that glitters as the morning sun hits it and then walk amongst the other pieces that vibrate with emotional energy.

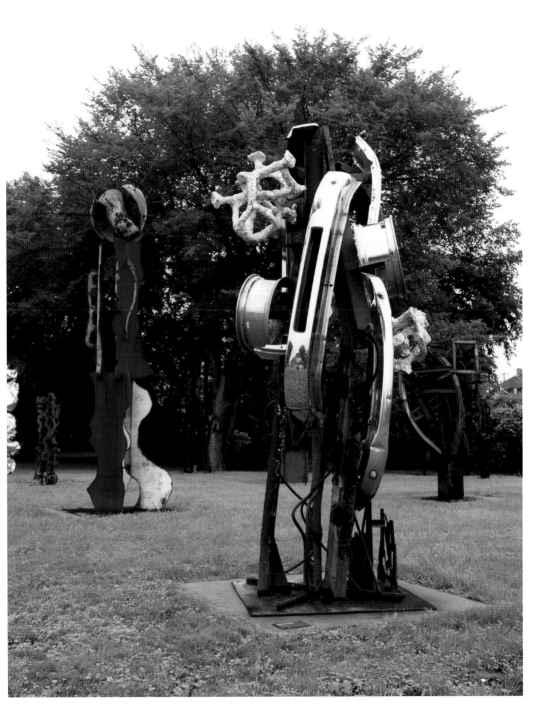

An abstract soldier stands watch in the rain at City Sculpture Park.

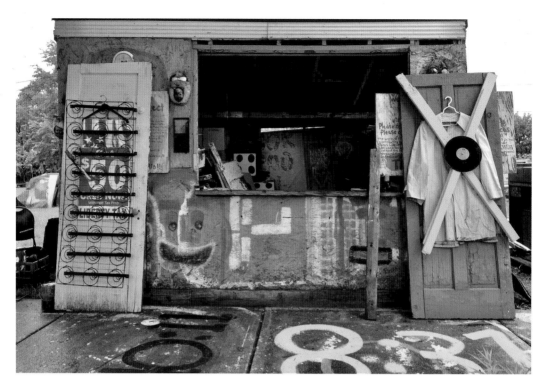

A piece of artwork at the Heidelberg Project.

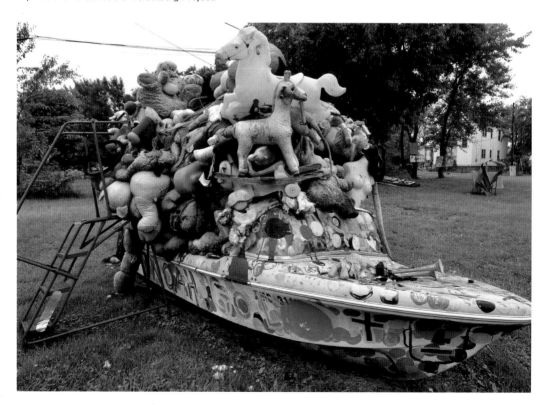

Stuffed animals take a boat ride at the Heidelberg Project.

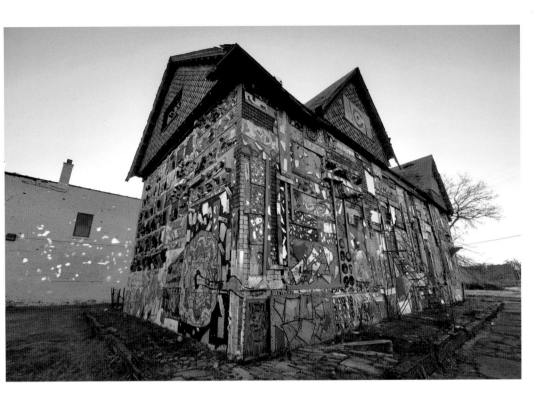

Above: The fantastical creation at the Dabls Mbad African Bead Museum outdoor installation.

Right: The Nice Outfit, a sculpture by Olayami Dabls.

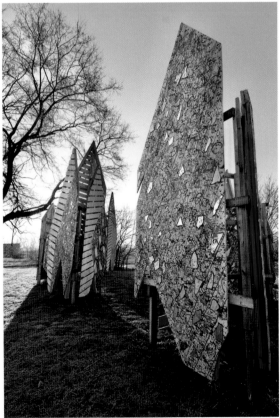

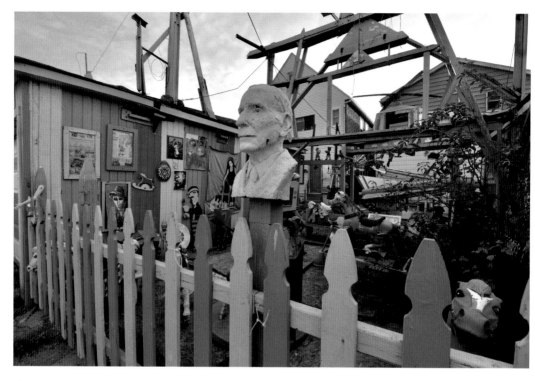

The colorful artwork of Hamtramck Disneyland.

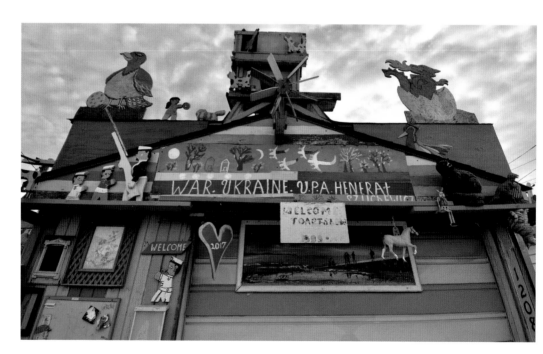

Dmytro Szyla's folk art legacy.